For my wife, Lillian, and my brother, and fellow animal nerd, Ben.—A.B.

For my parents, my brother, and Joëlle.—C.E.

ZooBorns

Introduction

ZooBorns showcases the newest and cutest baby animals at accredited zoos and aquariums around the world. However these adorable youngsters are much more than just cute, furry faces.

Baby animals born at zoos and aquariums represent new hope for their species in the wild. By studying rare or elusive species, zoo and aquarium researchers develop new conservation strategies for wild populations. Conservation breeding programs support reintroduction efforts and also help build assurance populations in the event that a species goes extinct in the wild.

The Association of Zoos and Aquariums (AZA) oversees Species Survival Plans for over 170 species, which includes identifying population management goals and making recommendations to ensure the long term sustainability of a healthy, genetically diverse, and demographically varied population.

The more you know about animals, the more you too can help protect them. So turn the page and meet the ZooBorns. Then visit your local accredited zoo or aquarium to learn more!

Paul Boyle, Ph.D.

Senior Vice President for Conservation and Education

Association of Zoos and Aquariums

The Association of Zoos and Aquariums sets high standards to make sure all the animals at accredited zoos and aquariums get the very best care.

A portion of all proceeds from ZooBorns book sales goes directly to the AZA's Conservation Endowment Fund.

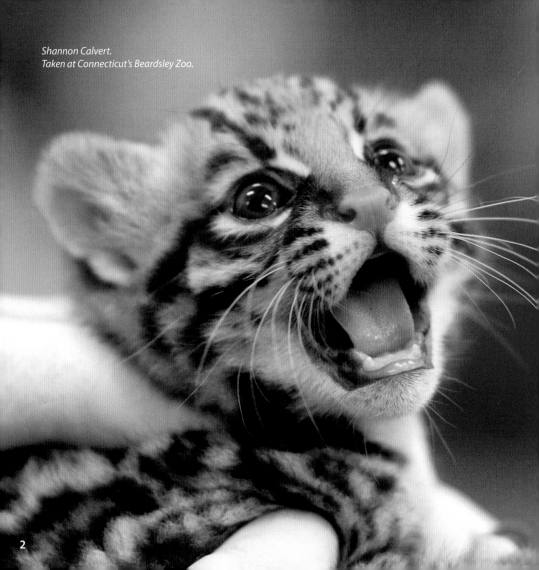

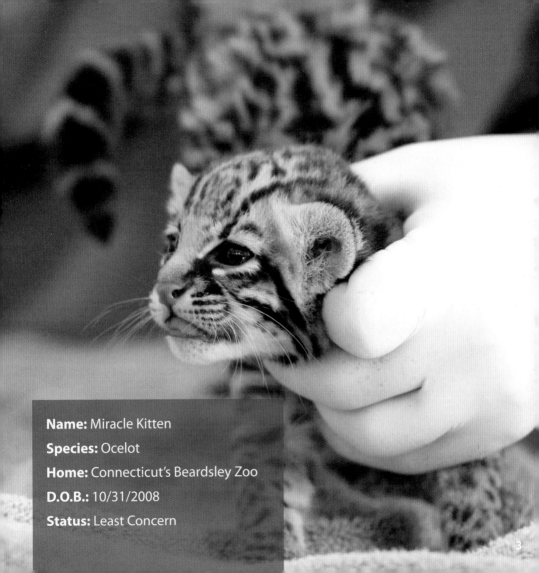

Name: Miracle Kitten
Species: Ocelot
Home: Connecticut's Beardsley Zoo
D.O.B.: 10/31/2008
Status: Least Concern

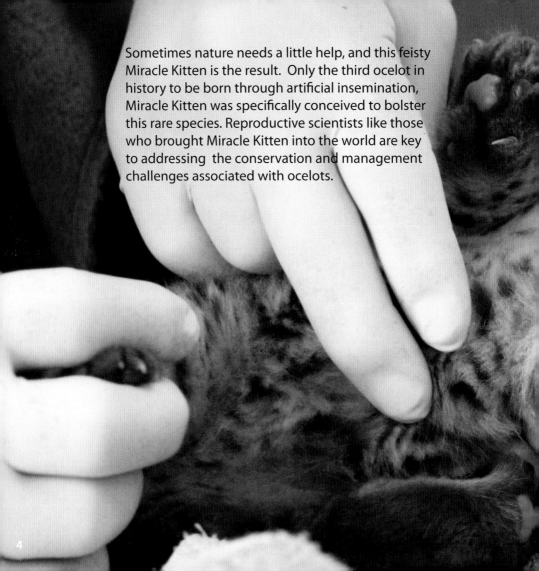

Sometimes nature needs a little help, and this feisty Miracle Kitten is the result. Only the third ocelot in history to be born through artificial insemination, Miracle Kitten was specifically conceived to bolster this rare species. Reproductive scientists like those who brought Miracle Kitten into the world are key to addressing the conservation and management challenges associated with ocelots.

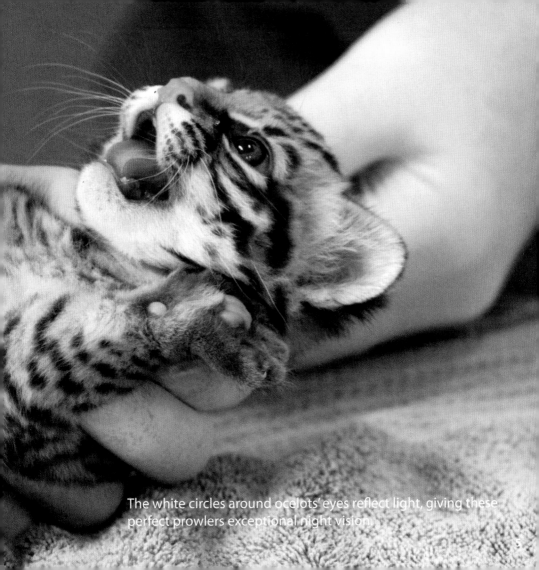

The white circles around ocelots' eyes reflect light, giving these perfect prowlers exceptional night vision.

9

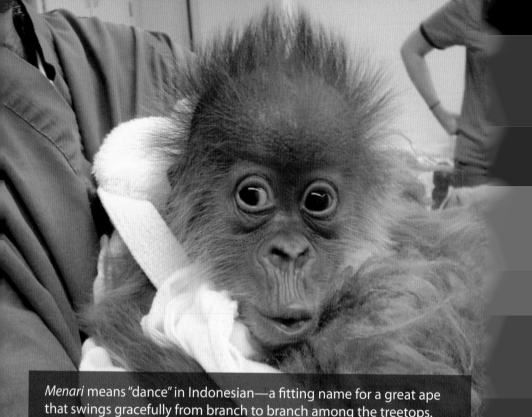

Menari means "dance" in Indonesian—a fitting name for a great ape that swings gracefully from branch to branch among the treetops.

Known for their intelligence, orangutans use tools to catch tasty termites and scrape stinging spines off their favorite fruits.

With only a few thousand Sumatran orangutans remaining in the wild, these red apes could soon become extinct in their native home.

Bob MacLean / Audubon Zoo

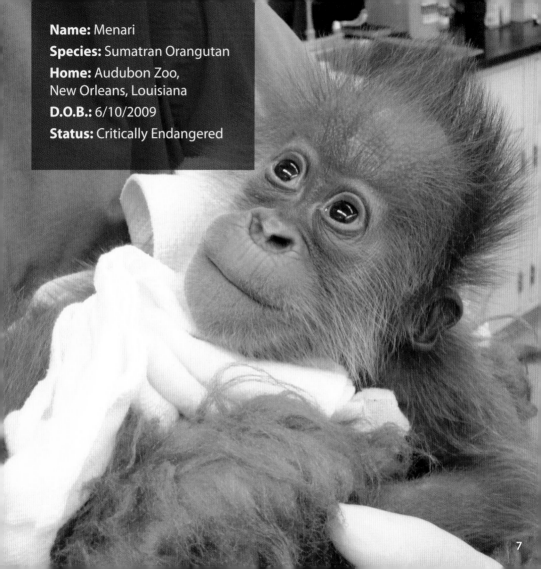

Name: Menari
Species: Sumatran Orangutan
Home: Audubon Zoo,
New Orleans, Louisiana
D.O.B.: 6/10/2009
Status: Critically Endangered

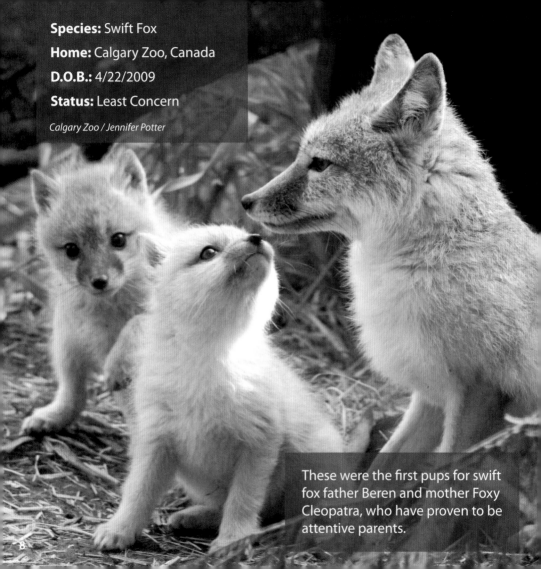

Species: Swift Fox
Home: Calgary Zoo, Canada
D.O.B.: 4/22/2009
Status: Least Concern

Calgary Zoo / Jennifer Potter

These were the first pups for swift fox father Beren and mother Foxy Cleopatra, who have proven to be attentive parents.

8

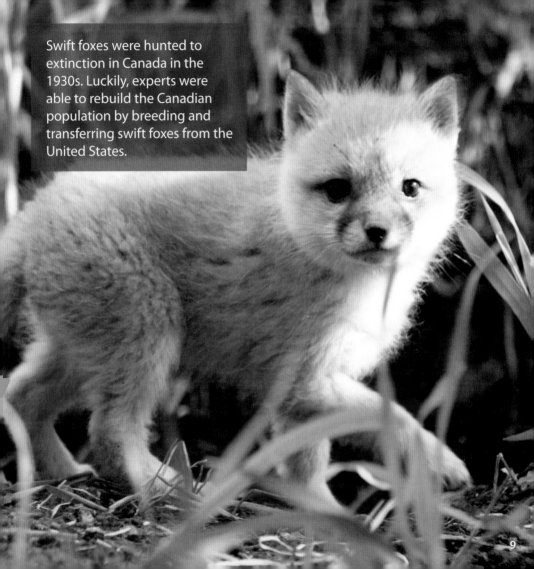

Swift foxes were hunted to extinction in Canada in the 1930s. Luckily, experts were able to rebuild the Canadian population by breeding and transferring swift foxes from the United States.

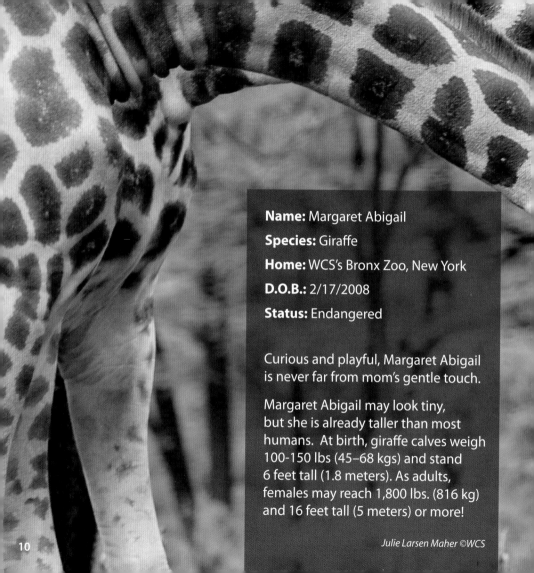

Name: Margaret Abigail
Species: Giraffe
Home: WCS's Bronx Zoo, New York
D.O.B.: 2/17/2008
Status: Endangered

Curious and playful, Margaret Abigail is never far from mom's gentle touch.

Margaret Abigail may look tiny, but she is already taller than most humans. At birth, giraffe calves weigh 100-150 lbs (45–68 kgs) and stand 6 feet tall (1.8 meters). As adults, females may reach 1,800 lbs. (816 kg) and 16 feet tall (5 meters) or more!

Julie Larsen Maher ©WCS

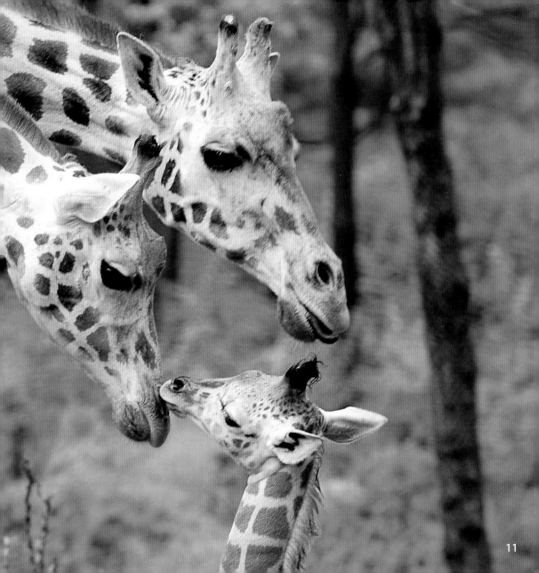

Name: Kit

Species: Sea Otter

Home: Monterey Bay Aquarium, California

D.O.B.: January 2010

Status: Endangered

The Monterey Bay Aquarium's Sea Otter Research and Conservation (SORAC) program has been studying and trying to save the threatened southern sea otter since 1984.

Kit came to the Aquarium as part of this program after the five-week-old pup was found stranded. Here she was introduced to a nine-year-old sea otter named Mae, who helps teach Kit how to groom herself, eat, dive, and play.

Sea otter populations are rebounding thanks to conservation efforts like SORAC. However, the species is still vulnerable to other threats like oil spills.

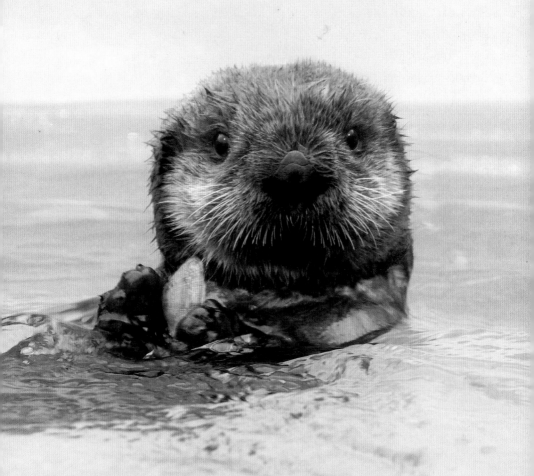

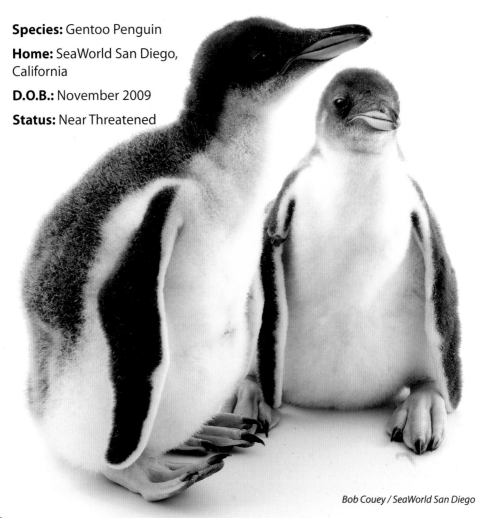

Species: Gentoo Penguin

Home: SeaWorld San Diego, California

D.O.B.: November 2009

Status: Near Threatened

Bob Couey / SeaWorld San Diego

For the first few months of life, penguin chicks have soft, downy feathers. After their first molt, this fluffy plumage is replaced by small, tightly packed feathers that will protect the penguins from frigid sub-Antarctic seas.

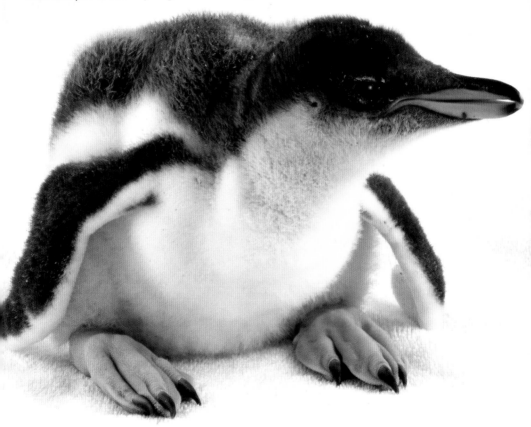

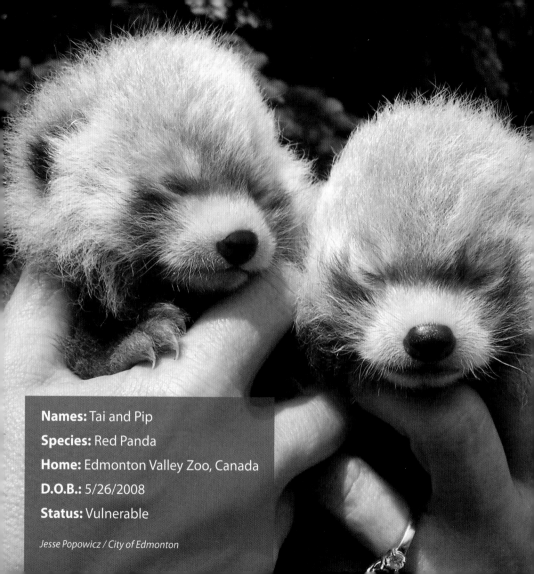

Names: Tai and Pip
Species: Red Panda
Home: Edmonton Valley Zoo, Canada
D.O.B.: 5/26/2008
Status: Vulnerable

Jesse Popowicz / City of Edmonton

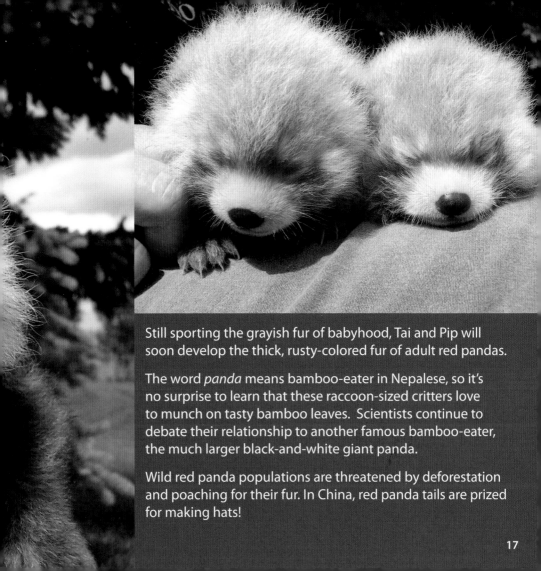

Still sporting the grayish fur of babyhood, Tai and Pip will soon develop the thick, rusty-colored fur of adult red pandas.

The word *panda* means bamboo-eater in Nepalese, so it's no surprise to learn that these raccoon-sized critters love to munch on tasty bamboo leaves. Scientists continue to debate their relationship to another famous bamboo-eater, the much larger black-and-white giant panda.

Wild red panda populations are threatened by deforestation and poaching for their fur. In China, red panda tails are prized for making hats!

Name: Sasa

Species: Banded Mongoose

Home: Fort Wayne Children's Zoo, Indiana

D.O.B.: 11/26/2009

Status: Least Concern

Cheryl Piropato / Fort Wayne Children's Zoo

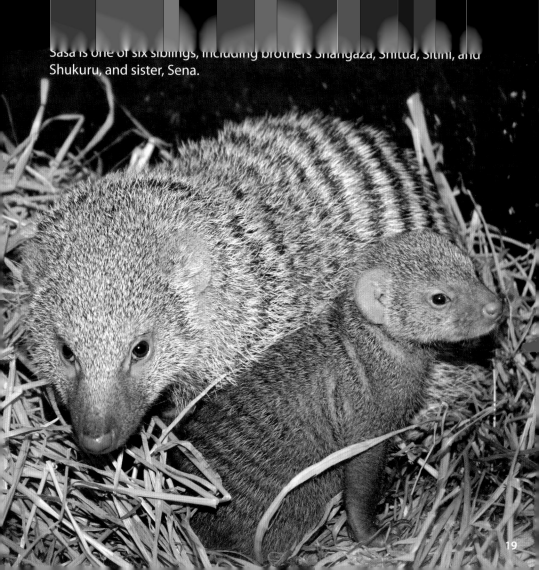

Sasa is one of six siblings, including brothers Shangaza, Shitua, Sitini, and Shukuru, and sister, Sena.

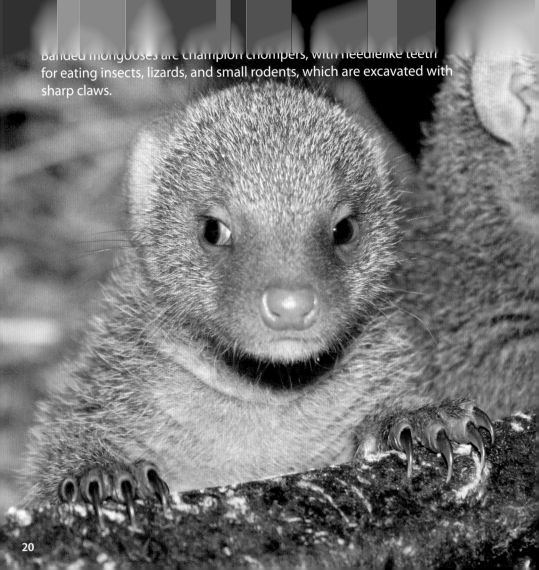

Banded mongooses are champion chompers, with needlelike teeth for eating insects, lizards, and small rodents, which are excavated with sharp claws.

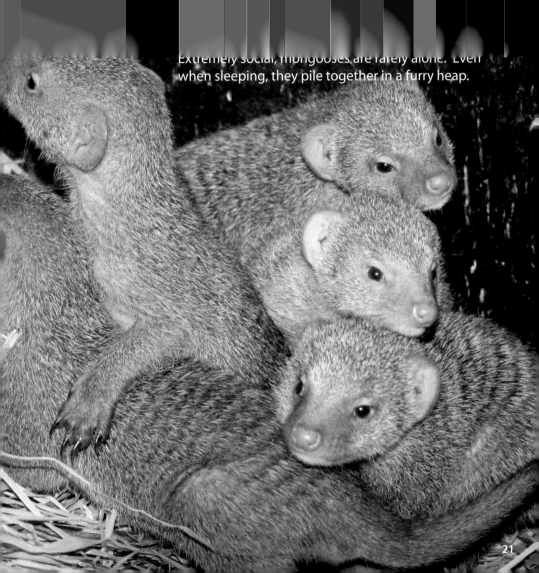

Extremely social, mongooses are rarely alone. Even when sleeping, they pile together in a furry heap.

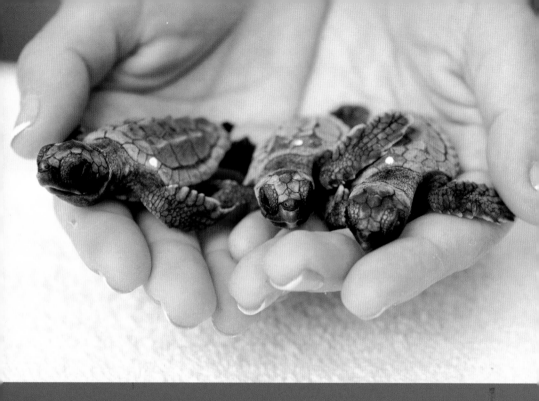

Species: Loggerhead Sea Turtle

Home: SeaWorld Orlando, Florida

D.O.B.: August 2009

Status: Endangered

Just one week old when Hurricane Bill struck, these loggerhead sea turtle hatchlings never completed their dangerous journey to the sea. Instead, they were scooped up by park rangers and sent to SeaWorld Orlando's Animal Rescue and Rehabilitation Team for a few days of pampering until the seas calmed down.

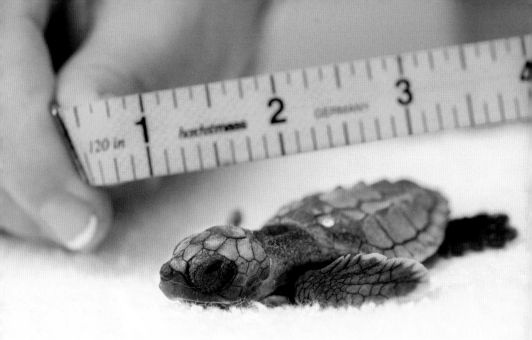

Though these little loggerheads made it to safety, many do not. Street lights and human activity can lure hatchlings toward traffic instead of the ocean.

In the United States, conservationists patrol beaches to locate turtle nests, count eggs, and protect them from beach visitors, dogs, and raccoons.

Jason Collier/SeaWorld

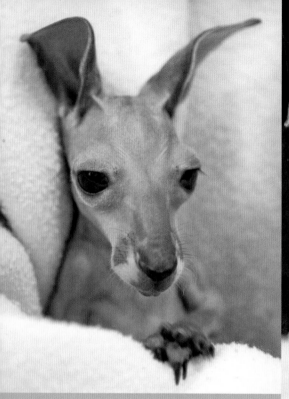

After falling from her mother's pouch, little Rooby was quickly rescued by zookeepers. But keepers were unable to determine which female 'roo had lost her joey, so they fashioned a fleece pouch for Rooby and successfully nursed her with a bottle.

Darlene Stack / Assiniboine Park Zoo

The largest of all kangaroos, red kangaroos can be found in nearly all parts of Australia.

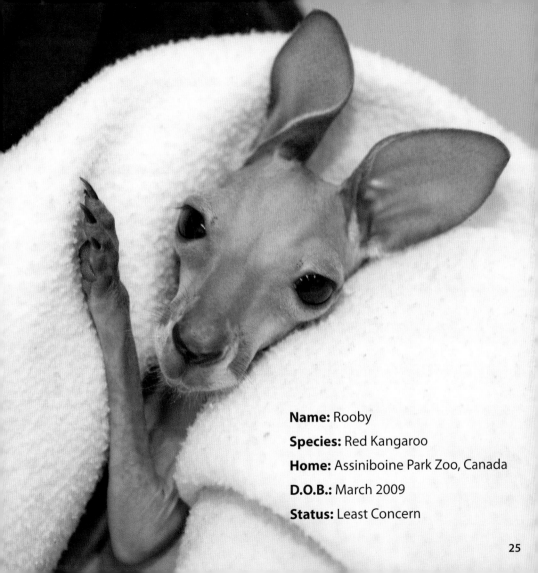

Name: Rooby

Species: Red Kangaroo

Home: Assiniboine Park Zoo, Canada

D.O.B.: March 2009

Status: Least Concern

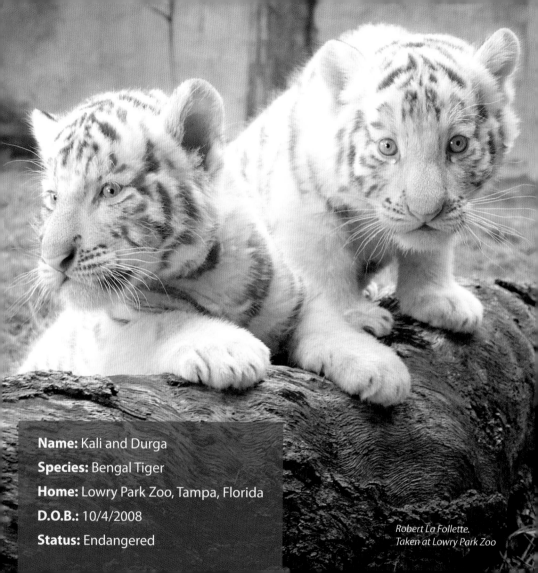

Name: Kali and Durga
Species: Bengal Tiger
Home: Lowry Park Zoo, Tampa, Florida
D.O.B.: 10/4/2008
Status: Endangered

Robert La Follette.
Taken at Lowry Park Zoo

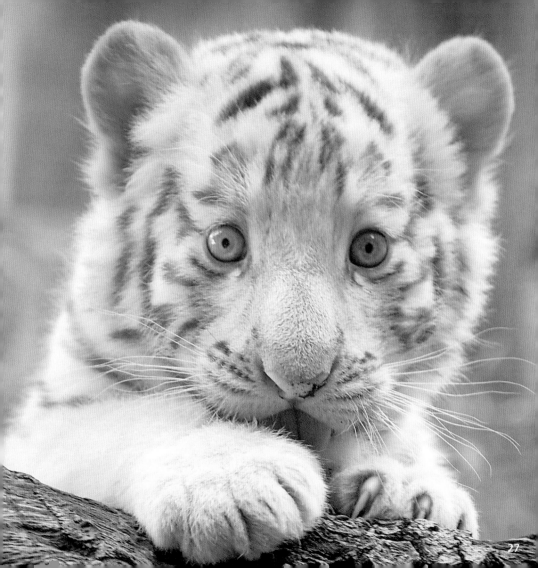

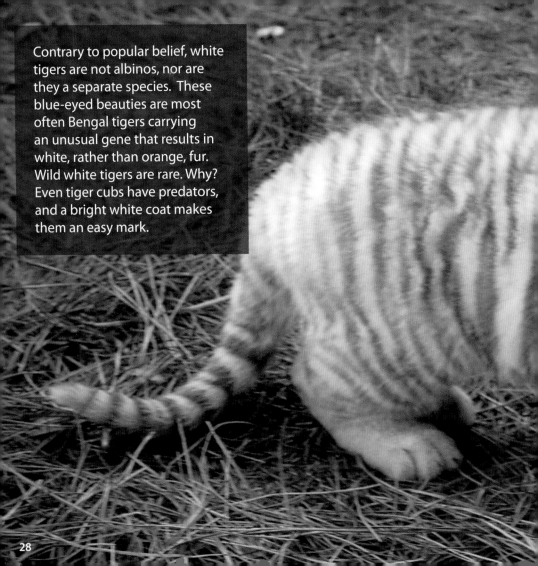

Contrary to popular belief, white tigers are not albinos, nor are they a separate species. These blue-eyed beauties are most often Bengal tigers carrying an unusual gene that results in white, rather than orange, fur. Wild white tigers are rare. Why? Even tiger cubs have predators, and a bright white coat makes them an easy mark.

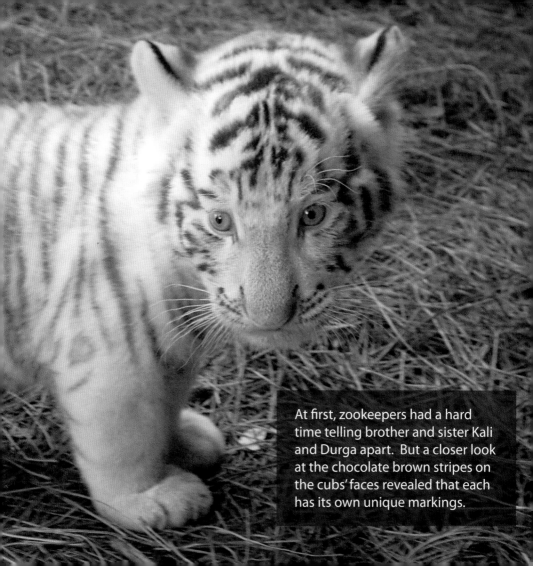

At first, zookeepers had a hard time telling brother and sister Kali and Durga apart. But a closer look at the chocolate brown stripes on the cubs' faces revealed that each has its own unique markings.

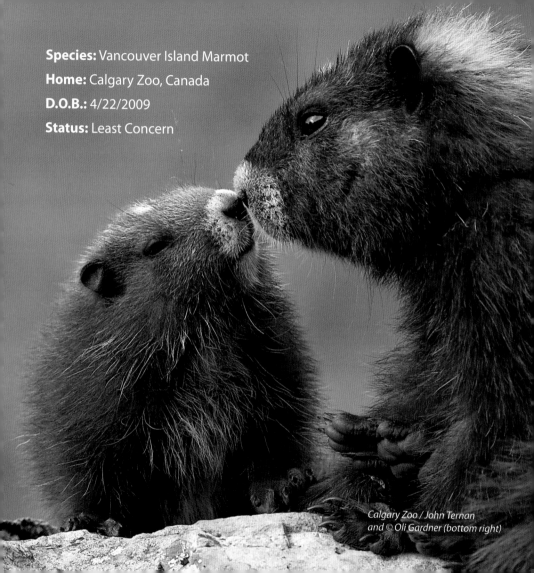

Species: Vancouver Island Marmot
Home: Calgary Zoo, Canada
D.O.B.: 4/22/2009
Status: Least Concern

Calgary Zoo / John Ternan
and © Oli Gardner (bottom right)

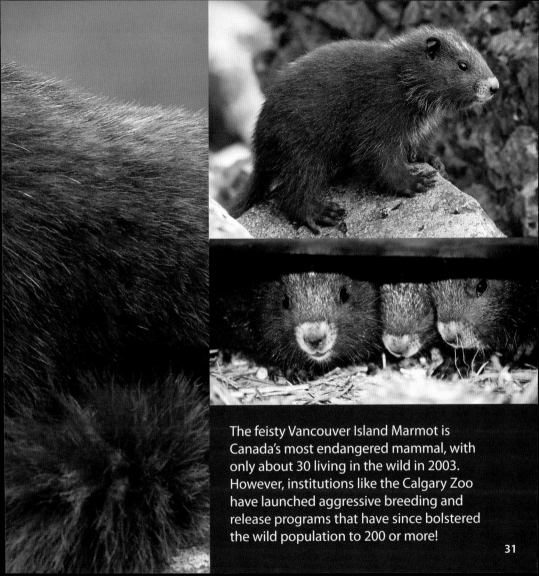

The feisty Vancouver Island Marmot is Canada's most endangered mammal, with only about 30 living in the wild in 2003. However, institutions like the Calgary Zoo have launched aggressive breeding and release programs that have since bolstered the wild population to 200 or more!

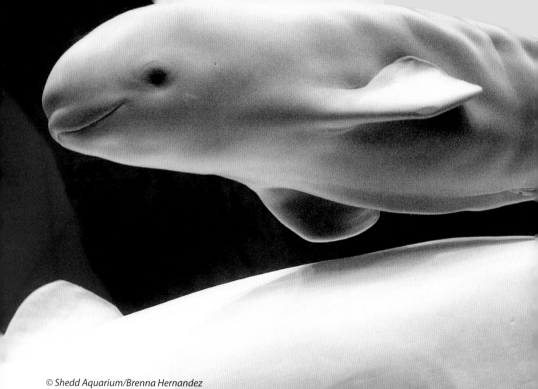

Name: Miki

Species: Beluga Whale

Home: Shedd Aquarium, Chicago, Illinois

D.O.B.: 8/16/2007

Status: Near Threatened

Often called "canaries of the sea," beluga whales squeal, chirp, cluck, and whistle to one another as they swim. Shedd Aquarium's whales even mimic the sounds of the scuba divers who clean their habitat!

Two layers of blubber keep wild belugas warm in the frigid Arctic waters.

Newborn calves like Miki sport on their sides big wrinkles called fetal folds. As the calf grows bigger, the folds smooth out.

When Miki was hungry, he would nudge mom's belly to let her know it was dinner time and to stimulate milk production.

33

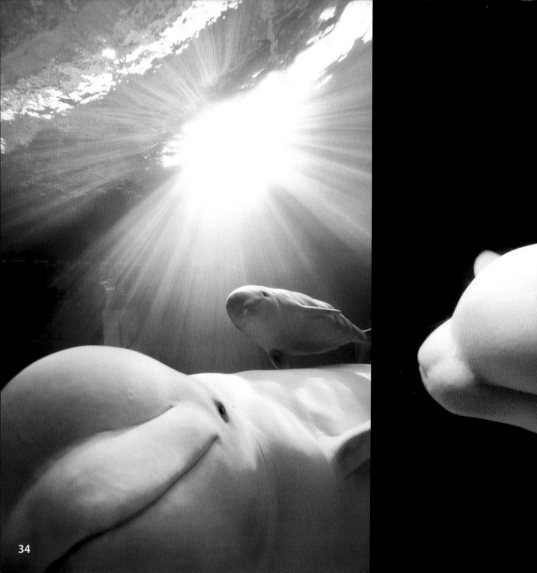

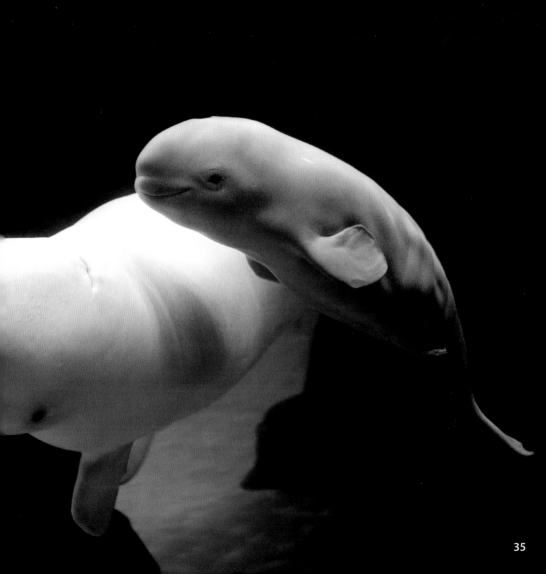

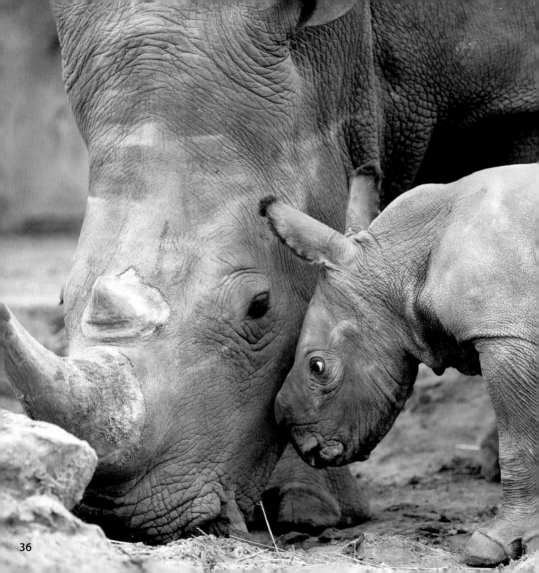

Species: White Rhinoceros

Home: Busch Gardens, Tampa Bay, Florida

D.O.B.: August 2009

Status: Near Threatened

The white rhinoceros is the second largest land mammal after the elephant, but that doesn't mean it's slow. White rhinos can run at speeds over 30 mph (50 kph)!

Busch Gardens participates in the Association of Zoos and Aquariums (AZA) Species Survival Plan (SSP) to ensure genetic diversification among threatened and endangered animals in zoos. This birth brings their total white rhino population to nine.

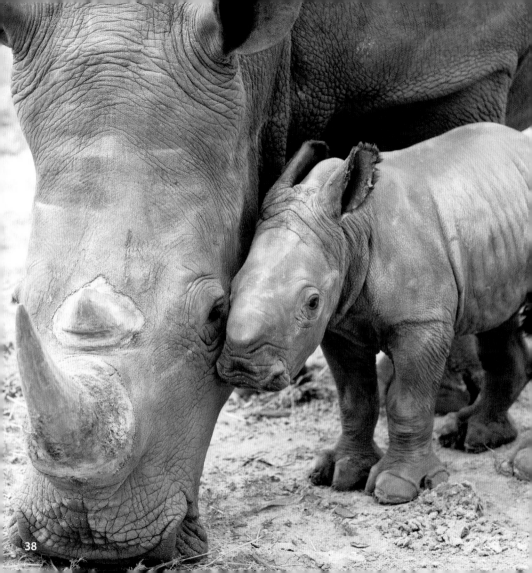

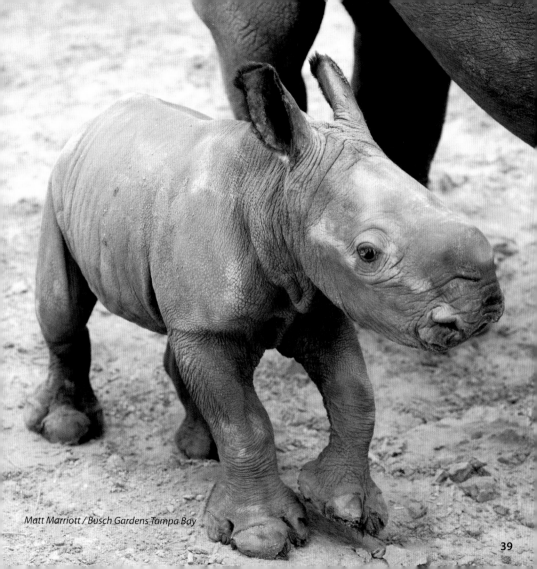
Matt Marriott / Busch Gardens Tampa Bay

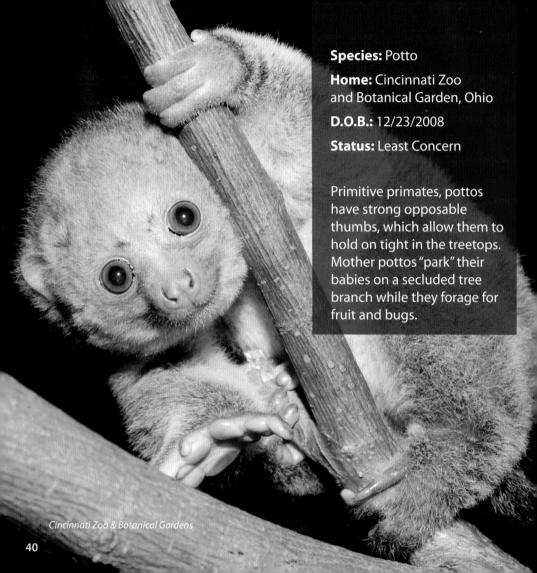

Species: Potto

Home: Cincinnati Zoo and Botanical Garden, Ohio

D.O.B.: 12/23/2008

Status: Least Concern

Primitive primates, pottos have strong opposable thumbs, which allow them to hold on tight in the treetops. Mother pottos "park" their babies on a secluded tree branch while they forage for fruit and bugs.

Cincinnati Zoo & Botanical Gardens

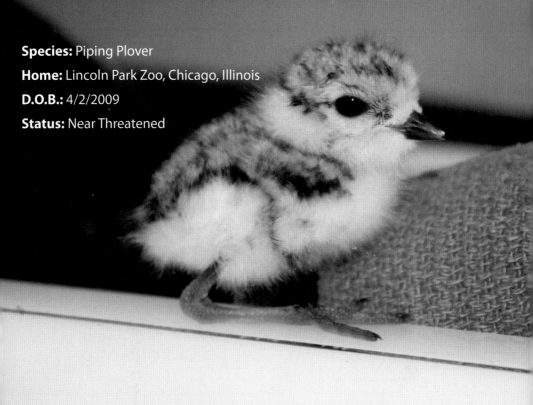

Species: Piping Plover

Home: Lincoln Park Zoo, Chicago, Illinois

D.O.B.: 4/2/2009

Status: Near Threatened

Nearly wiped out along the Great Lakes due to hunting and housing development, the piping plover has staged a small comeback thanks to conservation efforts like those at the Lincoln Park Zoo. This tiny plover was one of three hatched from abandoned eggs; all three were reared and released by the Zoo in 2009.

Joel Pond / Lincoln Park Zoo

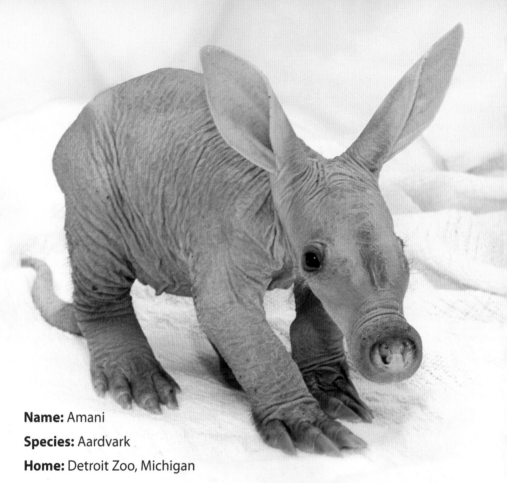

Name: Amani
Species: Aardvark
Home: Detroit Zoo, Michigan
D.O.B.: 12/8/2008
Status: Least Concern

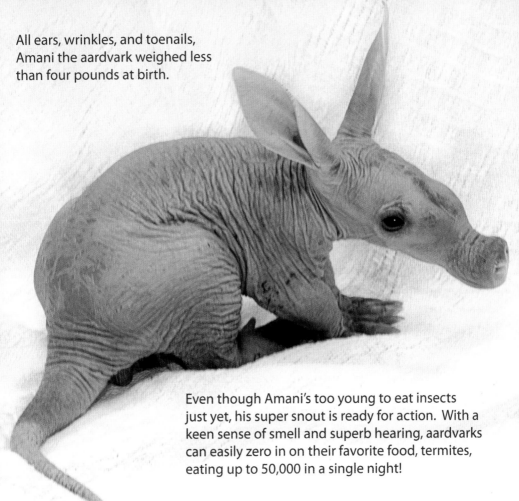

All ears, wrinkles, and toenails, Amani the aardvark weighed less than four pounds at birth.

Even though Amani's too young to eat insects just yet, his super snout is ready for action. With a keen sense of smell and superb hearing, aardvarks can easily zero in on their favorite food, termites, eating up to 50,000 in a single night!

Mark M. Gaskill - Phoenix Innovate. Taken at the Detroit Zoo

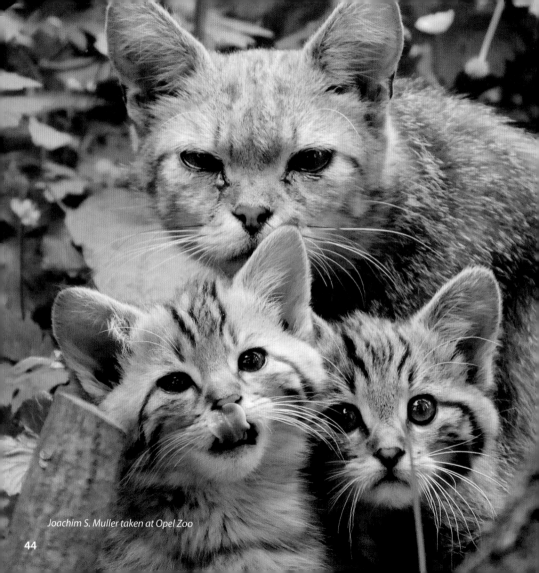

Joachim S. Muller taken at Opel Zoo

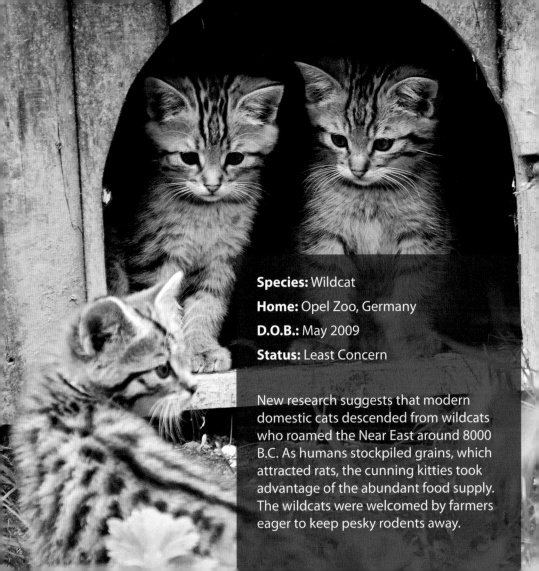

Species: Wildcat

Home: Opel Zoo, Germany

D.O.B.: May 2009

Status: Least Concern

New research suggests that modern domestic cats descended from wildcats who roamed the Near East around 8000 B.C. As humans stockpiled grains, which attracted rats, the cunning kitties took advantage of the abundant food supply. The wildcats were welcomed by farmers eager to keep pesky rodents away.

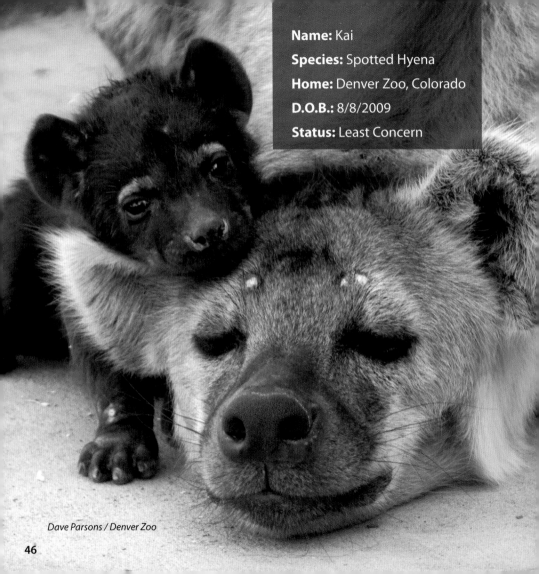

Name: Kai
Species: Spotted Hyena
Home: Denver Zoo, Colorado
D.O.B.: 8/8/2009
Status: Least Concern

Dave Parsons / Denver Zoo

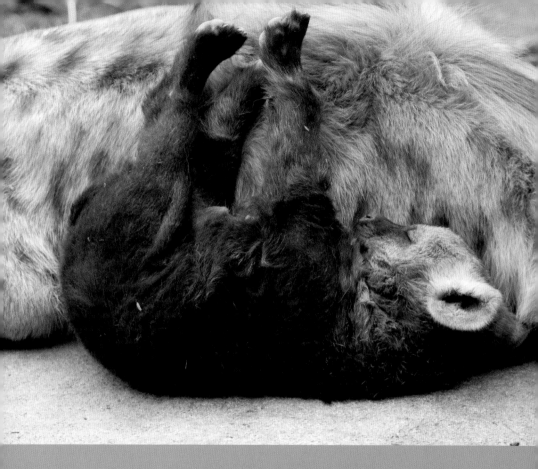

Clever little Kai is known for his precocious antics: playing hide-and-seek with mom, diving beneath logs, and exploring every corner of his exhibit. After a busy morning, Kai often falls asleep with legs pointed skyward, as if in mid-leap.

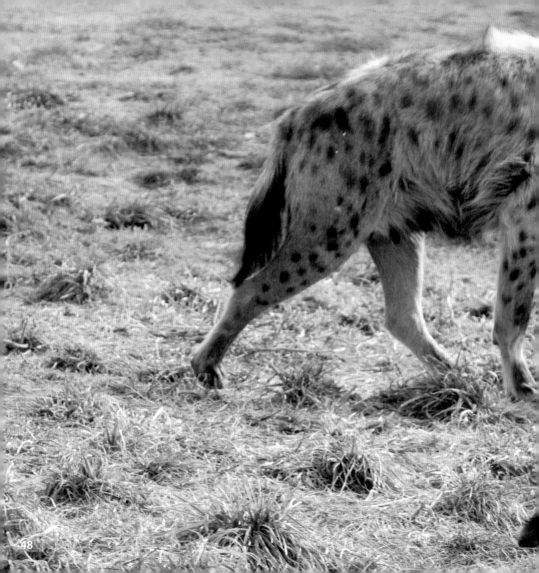

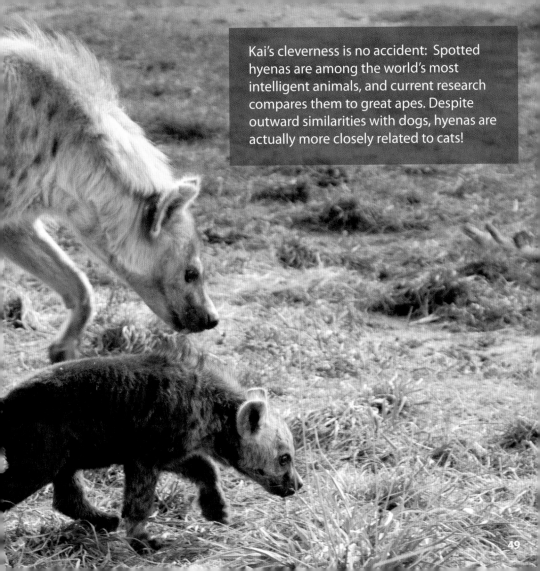

Kai's cleverness is no accident: Spotted hyenas are among the world's most intelligent animals, and current research compares them to great apes. Despite outward similarities with dogs, hyenas are actually more closely related to cats!

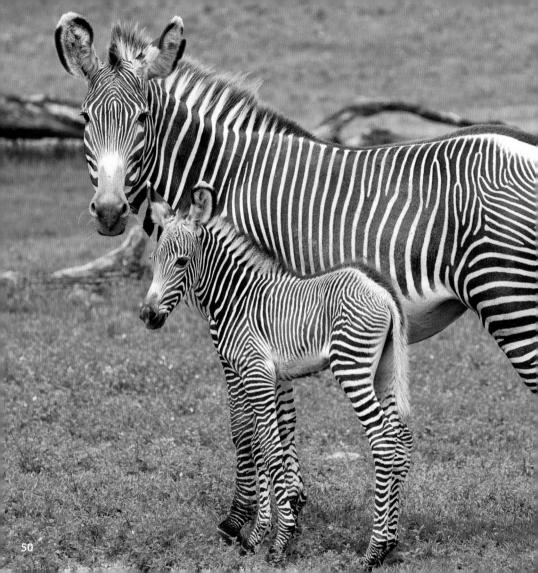

Species: Grevy's Zebra

Home: Busch Gardens, Tampa Bay, Florida

D.O.B.: May 2009

Status: Endangered

Never far from mom's side, Grevy's zebra foals stay with their herd for three years before striking out to join their own group.

The largest of all zebras, Grevy's zebra is endangered in its native home of Africa, where it is hunted for its striped hide and forced to compete with domestic livestock for grazing and water sources.

Well adapted to their arid surroundings, Grevy's zebra foals can go long periods without suckling and don't drink water until three months of age.

Matt Marriott / Busch Gardens, Tampa Bay

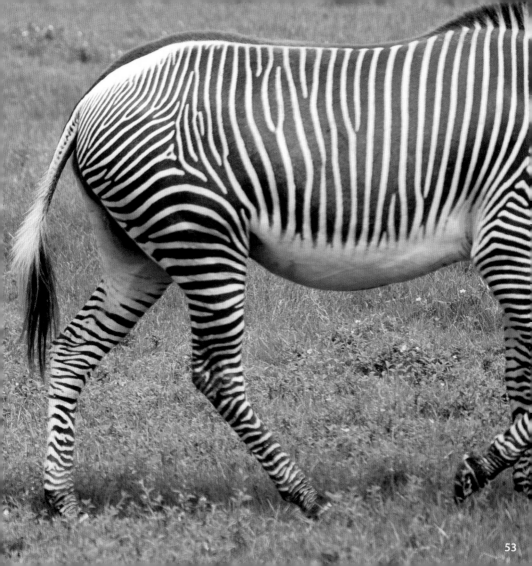

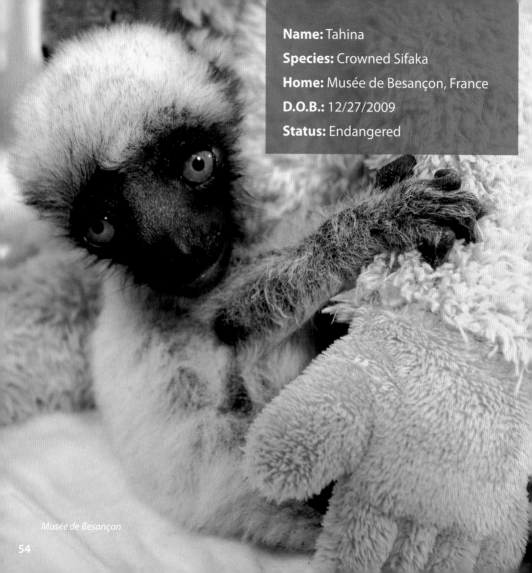

Name: Tahina
Species: Crowned Sifaka
Home: Musée de Besançon, France
D.O.B.: 12/27/2009
Status: Endangered

Musée de Besançon

54

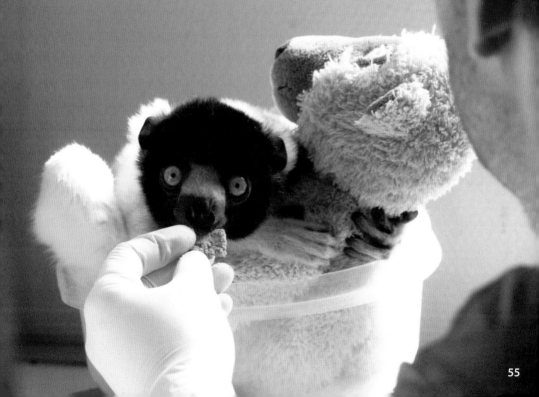

With her mother unable to care for her, tiny Tahina relied on zookeepers for nourishment and a stuffed teddy bear for comfort.

Crowned sifaka lemurs are found only in Madagascar, and their survival is threatened by deforestation. Less than 1,000 remain in the wild.

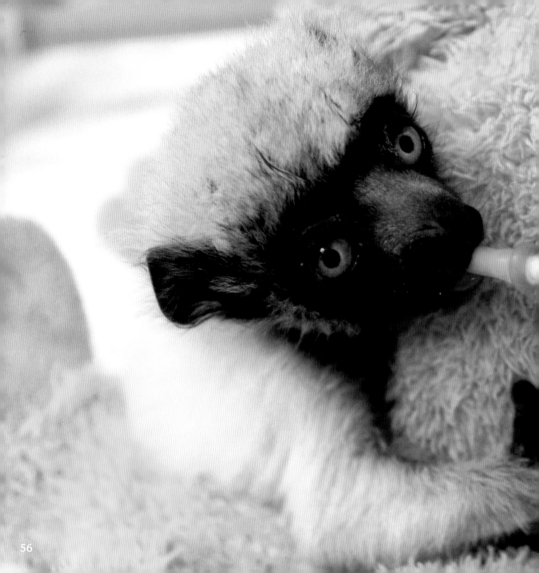

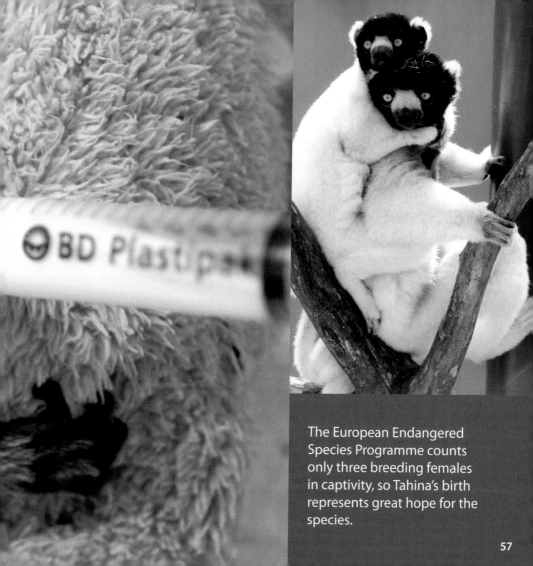

BD Plastipak

The European Endangered Species Programme counts only three breeding females in captivity, so Tahina's birth represents great hope for the species.

Names: Moa and Kain

Species: Short-beaked Echidna

Home: Perth Zoo, Australia

D.O.B.: August 2009

Status: Least Concern

Along with the platypus, echidnas are the only mammals that lay eggs. Newly hatched echidna babies are called puggles. They are born naked, without the spines that will protect them in adulthood.

Only thirteen echidnas, including Moa and Kain, have been bred in captivity in Australia, and five of those were at the Perth Zoo!

The echidna's tongue moves in and out rapidly when slurping up ants, as fast as 100 times per minute!

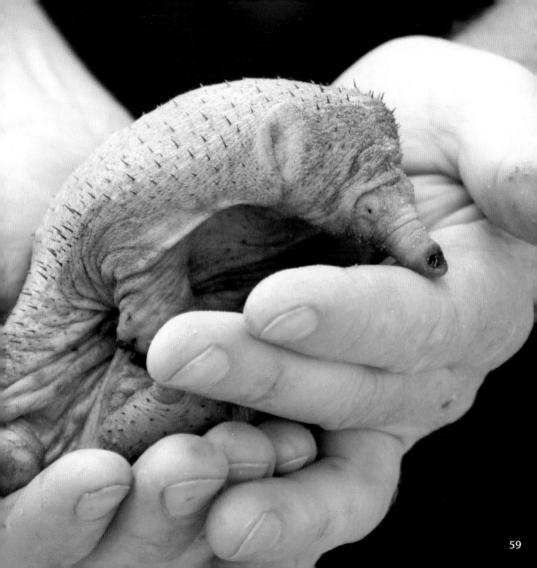

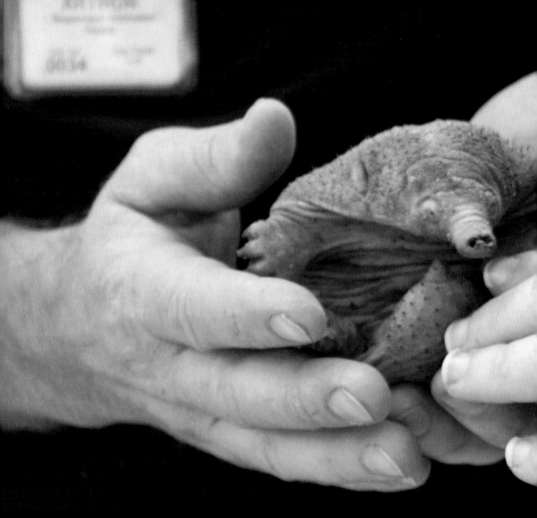

Daniel Scarparolo / Perth Zoo

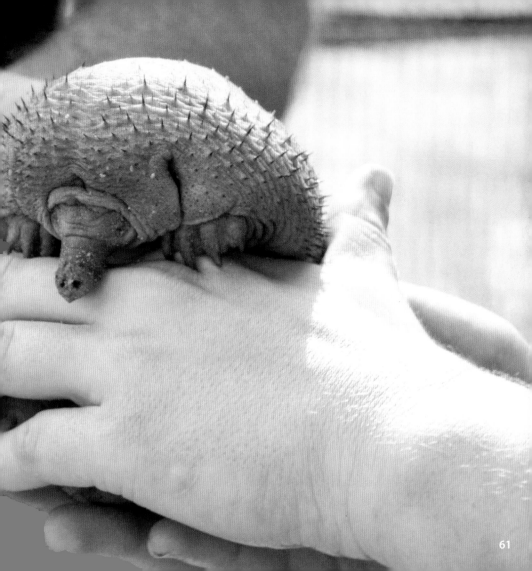

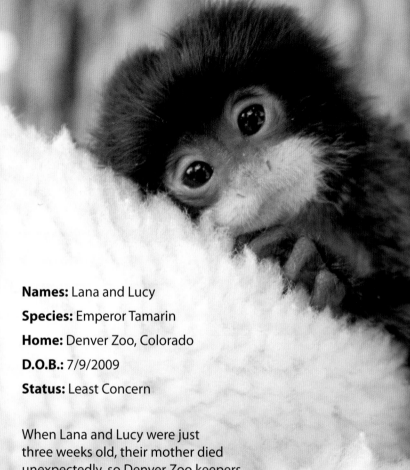

Names: Lana and Lucy

Species: Emperor Tamarin

Home: Denver Zoo, Colorado

D.O.B.: 7/9/2009

Status: Least Concern

When Lana and Lucy were just
three weeks old, their mother died
unexpectedly, so Denver Zoo keepers
rushed in to provide around-the-
clock care.

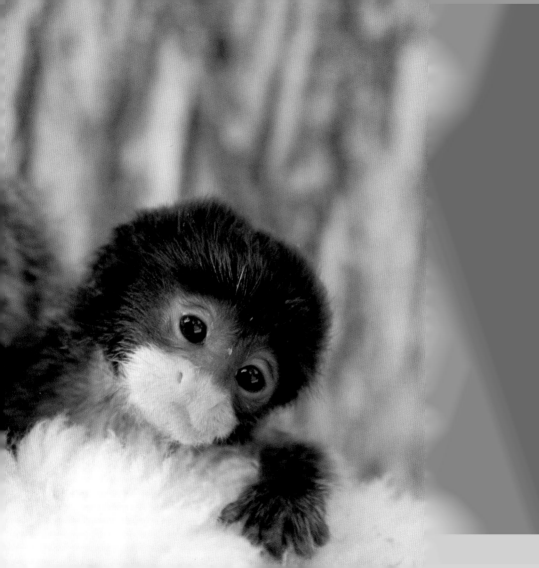

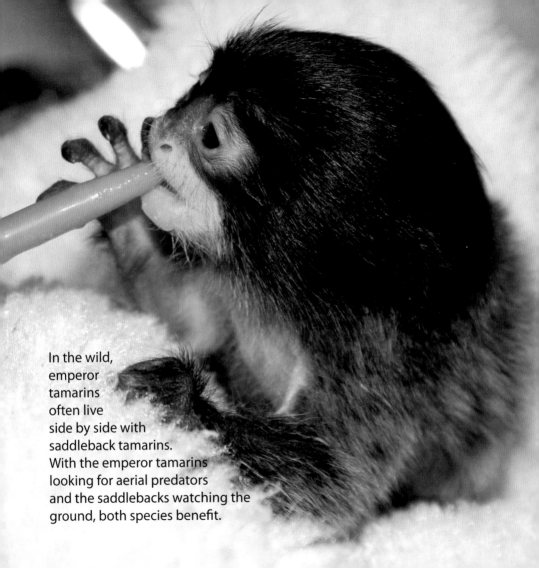

In the wild, emperor tamarins often live side by side with saddleback tamarins. With the emperor tamarins looking for aerial predators and the saddlebacks watching the ground, both species benefit.

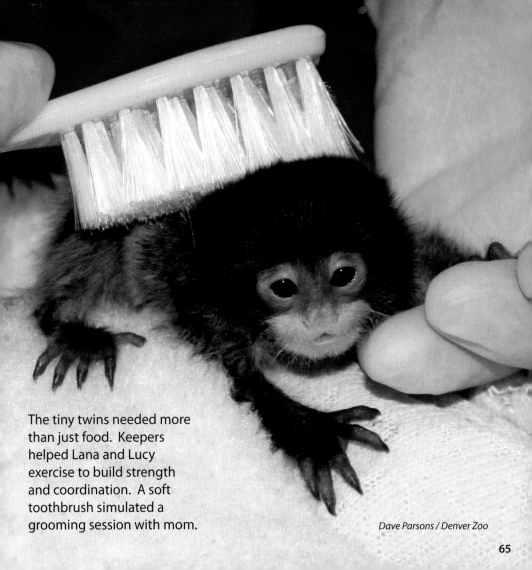

The tiny twins needed more than just food. Keepers helped Lana and Lucy exercise to build strength and coordination. A soft toothbrush simulated a grooming session with mom.

Dave Parsons / Denver Zoo

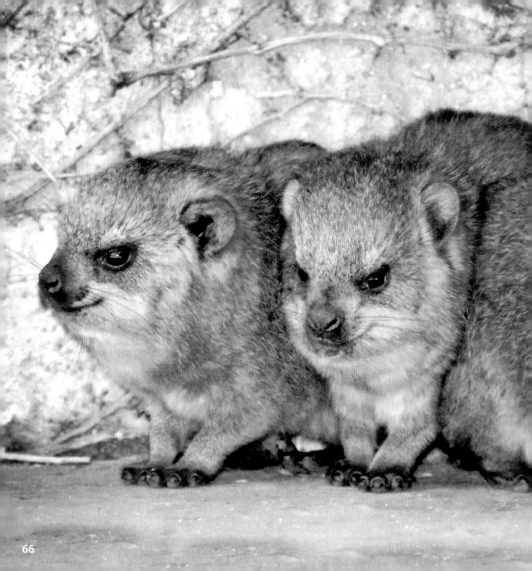

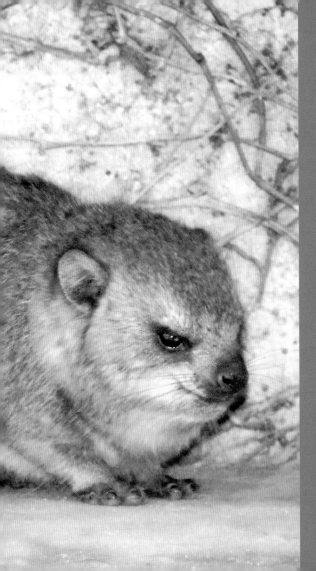

Species: Rock Hyrax

Home: Los Angeles Zoo, California

D.O.B.: 7/12/2009

Status: Least Concern

They may look like oversized guinea pigs, but these five-day-old hyraxes are more closely related to elephants. In prehistoric times, some hyrax species reached the size of a small horse!

Groups of up to eighty rock hyraxes live together and search for grasses and leaves. While the herd forages, one or two hyraxes will serve sentry duty, perching high on a rock to look for danger.

Tad Motoyama / Los Angeles Zoo

The Woodland Park Zoo partners with the Center for Wildlife Conservation and the Washington Department of Fish & Wildlife to rebuild the Western Pond Turtle population.

By protecting wild nests from predators with screen cages and caring for new hatchlings until they are able to fend for themselves, the Zoo gives these turtles a head-start.

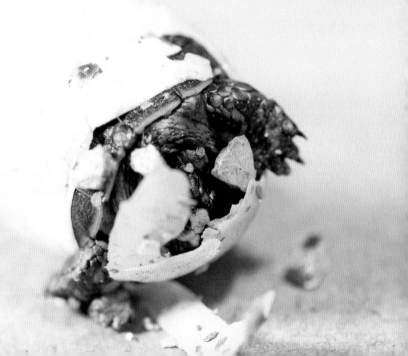

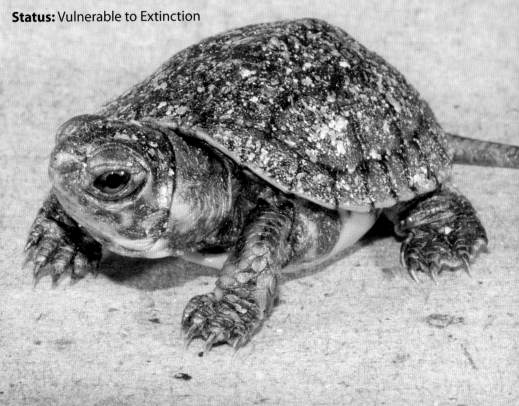

Species: Western Pond Turtle

Home: Woodland Park Zoo, Seattle, Washington

D.O.B.: October 2008

Status: Vulnerable to Extinction

Ryan Hawk / Woodland Park Zoo

Name: Pan
Species: Aye-aye
Home: Denver Zoo, Colorado
D.O.B.: 4/18/2009
Status: Near Threatened

With glowing eyes, bizarre fingers, and nocturnal habits, aye-ayes are considered bad omens by local villagers, who persecute these rare creatures. But aye-ayes are gentle lemurs that use their long, crooked fingers to extract grubs from under tree bark.

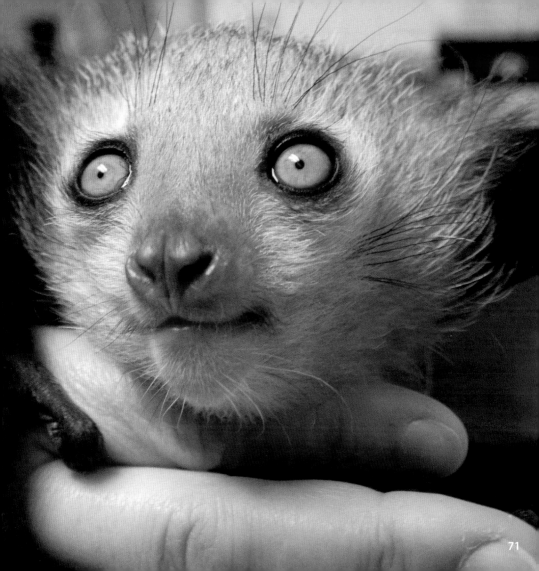

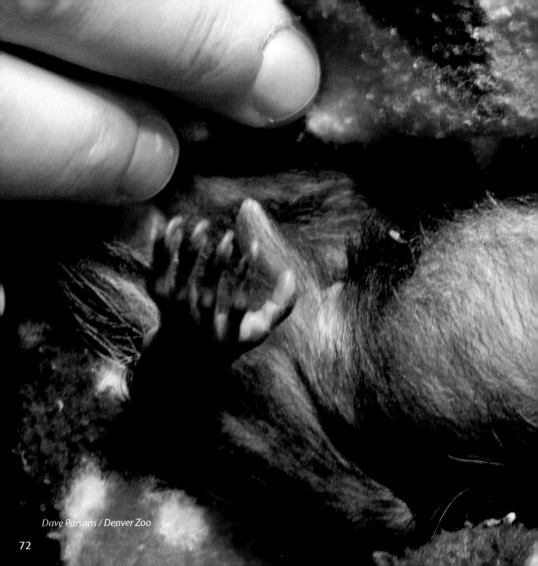

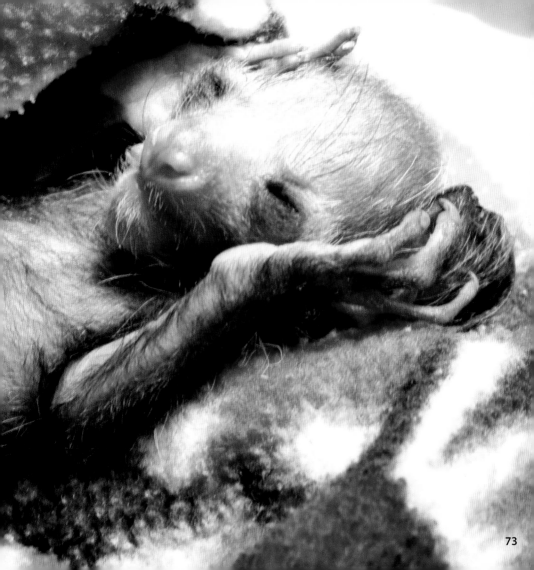

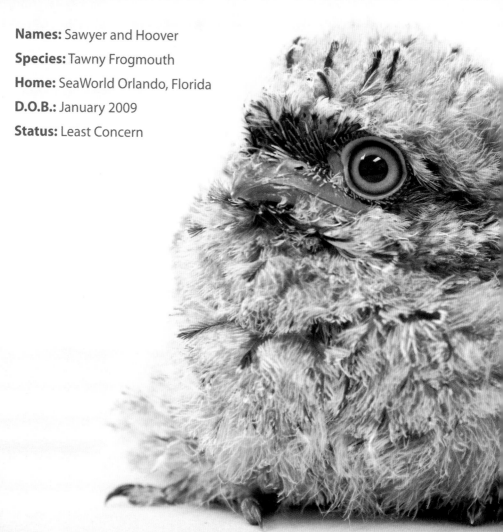

Names: Sawyer and Hoover
Species: Tawny Frogmouth
Home: SeaWorld Orlando, Florida
D.O.B.: January 2009
Status: Least Concern

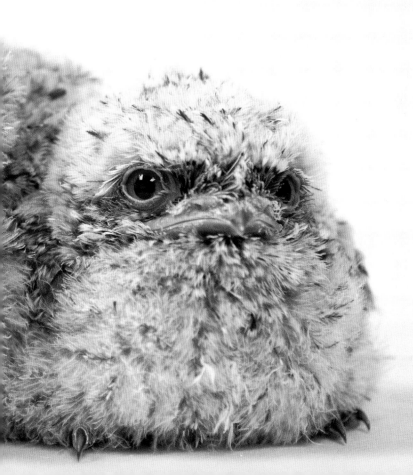

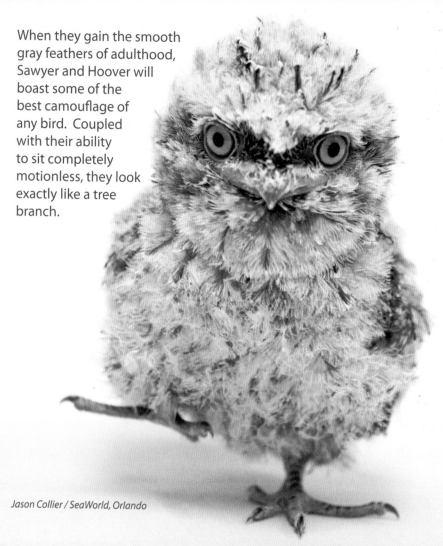

When they gain the smooth gray feathers of adulthood, Sawyer and Hoover will boast some of the best camouflage of any bird. Coupled with their ability to sit completely motionless, they look exactly like a tree branch.

Jason Collier / SeaWorld, Orlando

Often confused with owls because of their appearance and nocturnal hunting habits, tawny frogmouths are actually related to nightjars.

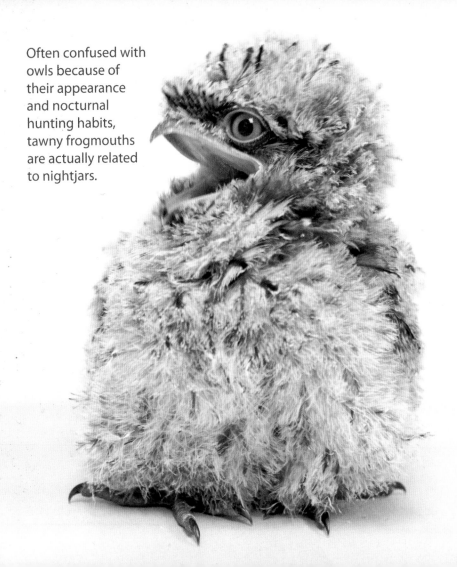

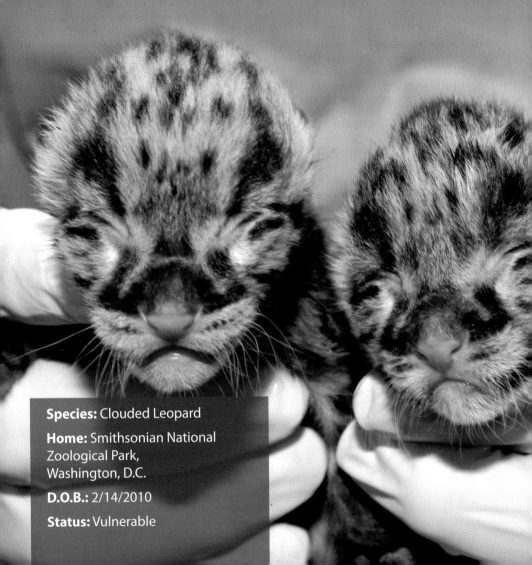

Species: Clouded Leopard

Home: Smithsonian National
Zoological Park,
Washington, D.C.

D.O.B.: 2/14/2010

Status: Vulnerable

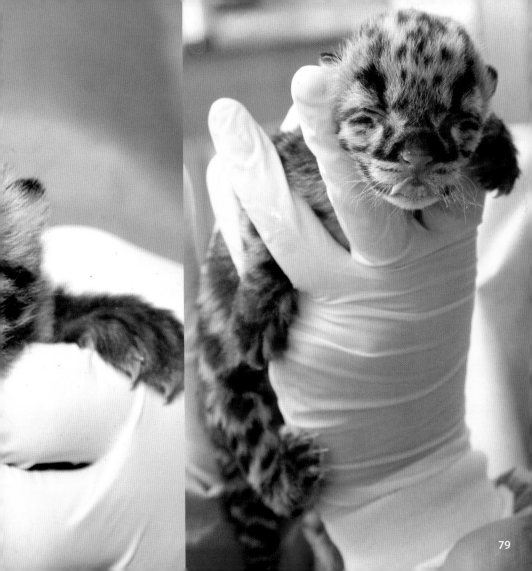

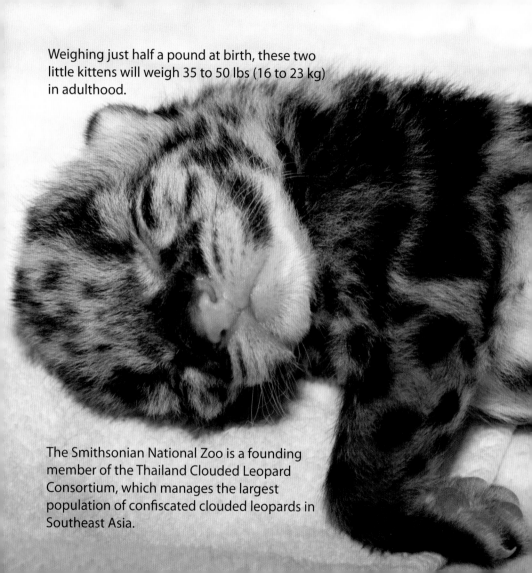

Weighing just half a pound at birth, these two little kittens will weigh 35 to 50 lbs (16 to 23 kg) in adulthood.

The Smithsonian National Zoo is a founding member of the Thailand Clouded Leopard Consortium, which manages the largest population of confiscated clouded leopards in Southeast Asia.

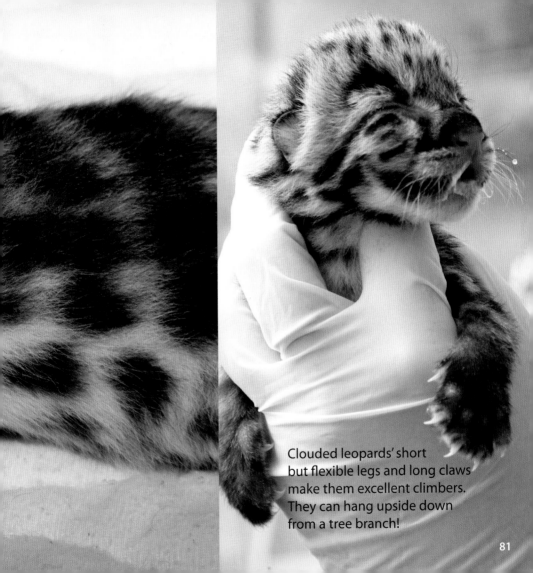

Clouded leopards' short but flexible legs and long claws make them excellent climbers. They can hang upside down from a tree branch!

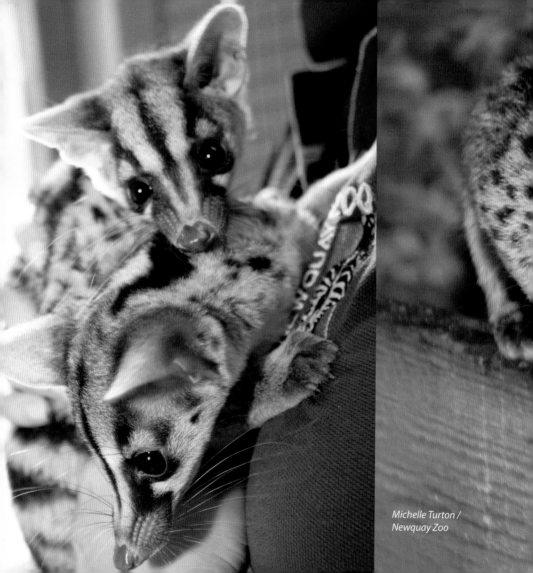

Michelle Turton /
Newquay Zoo

Species: Owston's Palm Civet

Home: Newquay Zoo, United Kingdom

D.O.B.: 4/30/2009

Status: Vulnerable

As a participant in the Vietnamese Carnivore and Pangolin Programme, the Zoo also trains rangers in Cuc Phuong National Park in Vietnam and supports local education and research projects.

Newquay Zoo breeds rare Owston's Palm Civets, which are threatened by poachers in their native home of Vietnam. Little is known about these shy, tree-dwelling animals.

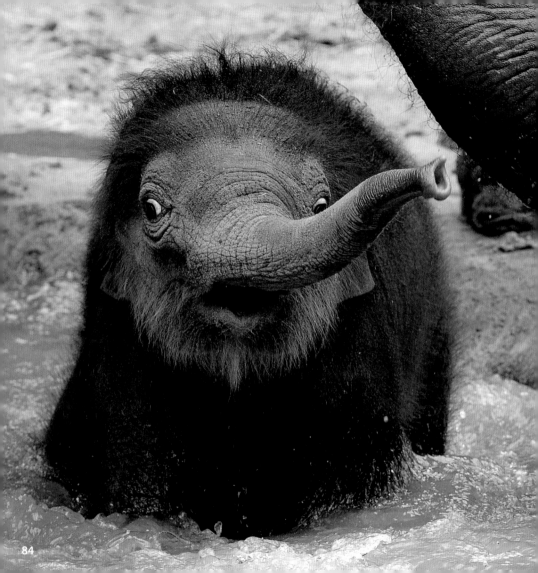

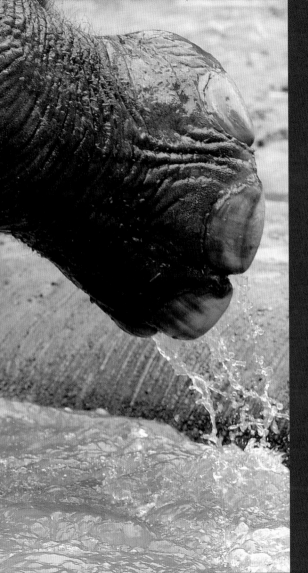

Name: Mali

Species: Asian Elephant

Home: Melbourne Zoo, Australia

D.O.B.: 1/16/10

Status: Endangered

Mali is Melbourne Zoo's first baby elephant, and her playfulness makes her a real standout. Whether splashing in her pool or harassing the adult elephants, Mali is always on the lookout for fun.

Made up of over 40,000 different muscles, elephants' trunks are powerful and flexible but they are also sensitive. While many elephants can lift over 800 lbs (363 kg) with their trunks, they can also pick up a single leaf.

AFP/Getty Images

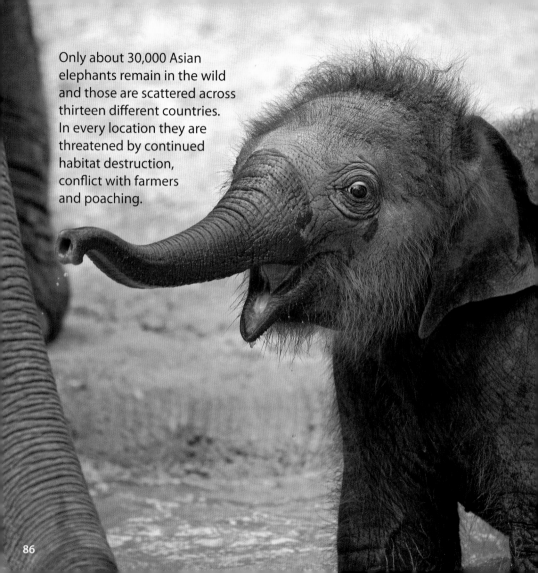

Only about 30,000 Asian elephants remain in the wild and those are scattered across thirteen different countries. In every location they are threatened by continued habitat destruction, conflict with farmers and poaching.

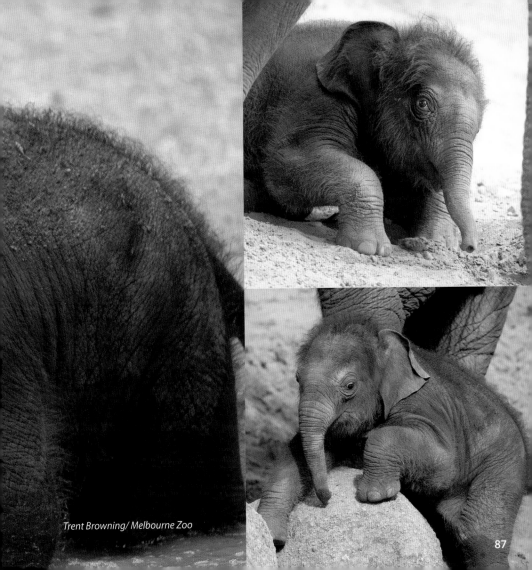

Trent Browning/ Melbourne Zoo

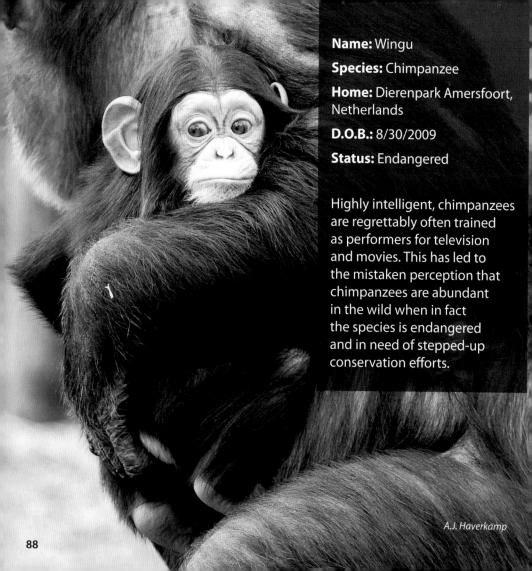

Name: Wingu

Species: Chimpanzee

Home: Dierenpark Amersfoort, Netherlands

D.O.B.: 8/30/2009

Status: Endangered

Highly intelligent, chimpanzees are regrettably often trained as performers for television and movies. This has led to the mistaken perception that chimpanzees are abundant in the wild when in fact the species is endangered and in need of stepped-up conservation efforts.

A.J. Haverkamp

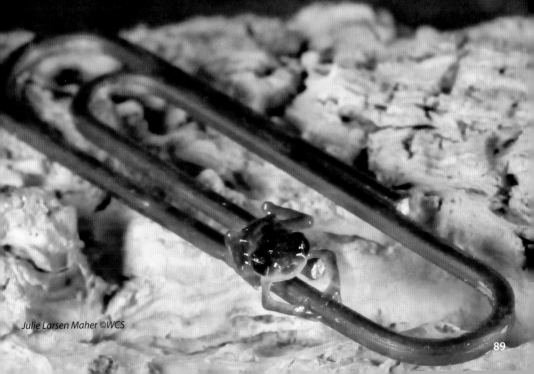

Species: Kihansi Spray Toad

Home: WCS's Bronx Zoo, New York

D.O.B.: January 2010

Status: Extinct in the Wild

When Tanzania built a massive hydroelectric dam in the Kihansi Gorge, this tiny toad lost 90% of its habitat. Luckily, researchers from the Wildlife Conservation Society's Bronx Zoo collected an "insurance colony" of 499 toads. They've since figured out how to keep the little toads comfortable and, more important, how to encourage them to produce baby toads!

Julie Larsen Maher ©WCS

Species: Columbia Basin Pygmy Rabbit

Home: Oregon Zoo, Portland

D.O.B.: 7/12/2009

Status: Extinct

Native to a single area of Washington State, these tiny bunnies went extinct in the wild in the 1990s when researchers collected the fourteen known remaining rabbits to build a viable breeding population.

Unlike most rabbits, the Columbia Basin pygmy rabbit did not breed prodigiously in captivity, partially due to inbreeding within the tiny wild population. To improve the odds, they were crossbred with Idaho pygmy rabbits, which paid off.

Seventy-three bunny kits were born in zoos and breeding facilities in 2009, including twenty-six at the Oregon Zoo. Color is added to the ears so zoo staff can tell the kits apart.

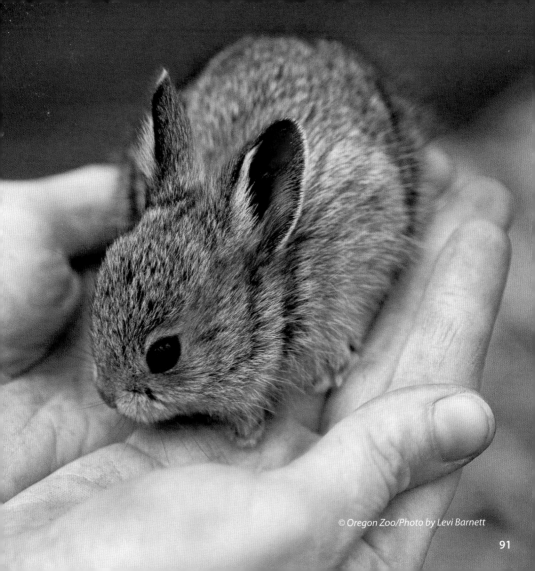

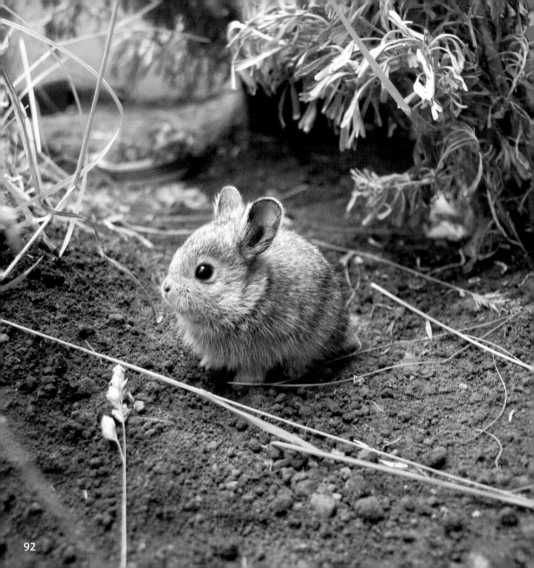

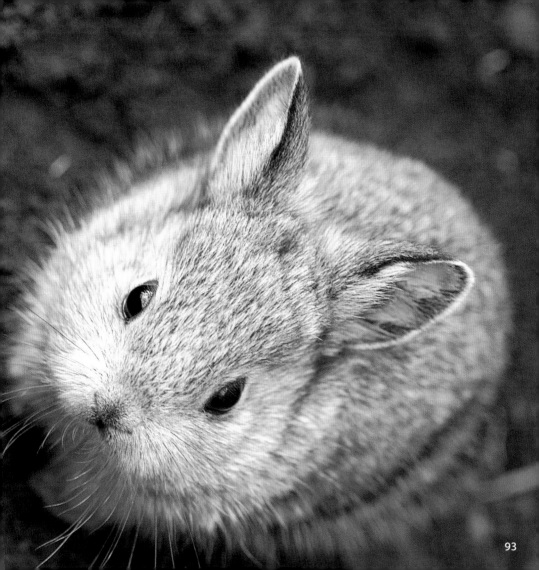

Name: Nino

Species: Southern Three-banded Armadillo

Home: Minnesota Zoo

D.O.B.: 2/19/2009

Status: Near Threatened

Three-banded armadillos produce only one baby at a time, and newborns like little Nino are about the size of a golf ball!

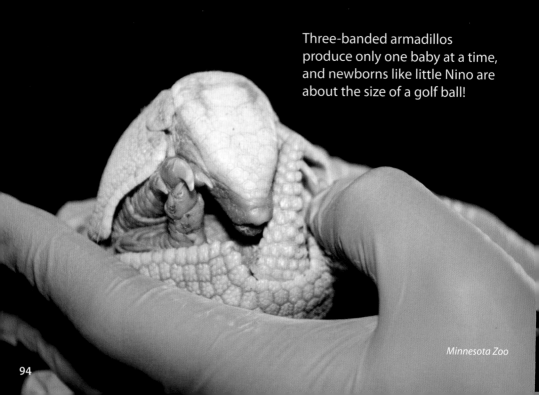

Minnesota Zoo

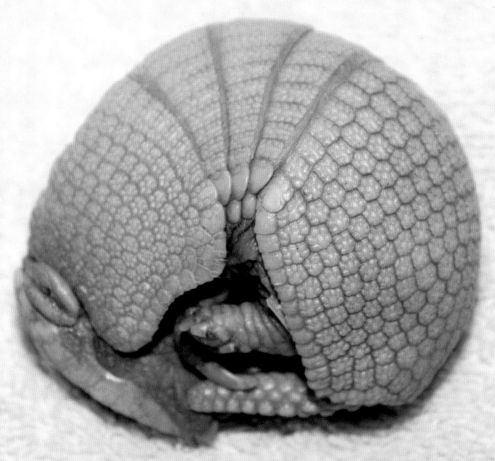

Their hard shell, which covers most of the body and much of the head, is made of keratin, the same material as human fingernails.

SeaWorld used sex-selection techniques to ensure this calf was female, allowing them to optimally balance their ratio of males and females.

Celebrated for their playfulness and intelligence, bottlenose dolphins have demonstrated considerable evidence of self-awareness, including recognizing themselves in mirrors!

Mike Aguilera / SeaWorld San Diego

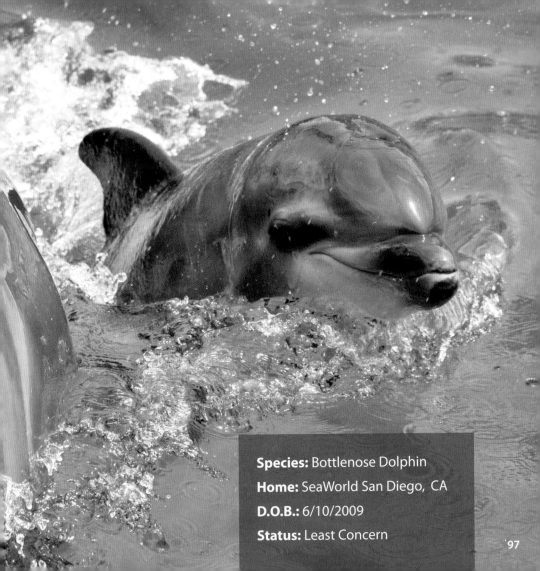

Species: Bottlenose Dolphin
Home: SeaWorld San Diego, CA
D.O.B.: 6/10/2009
Status: Least Concern

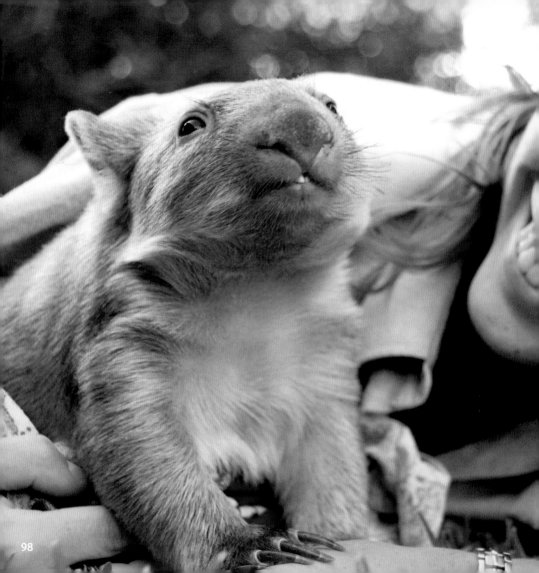

Name: Matari

Species: Common Wombat

Home: Taronga Zoo, Australia

D.O.B.: July 2008

Status: Least Concern

Matari means "little man" in Aboriginal, and when the orphan wombat was dropped off at the Taronga Zoo, he was underweight as well as stressed and missing patches of fur.

Like all wombats, Matari is nocturnal. His first nights at the zoo, he played in his pen until the wee hours, keeping his surrogate zookeeper mother wide awake.

Because Matari is a marsupial, he likes to curl up in a pillowcase, which reminds him of his mother's pouch.

After a few weeks at the Taronga Zoo, keepers took Matari outside to play and were proud to see him instinctively digging in the dirt and eating grass roots, just like a wild wombat!

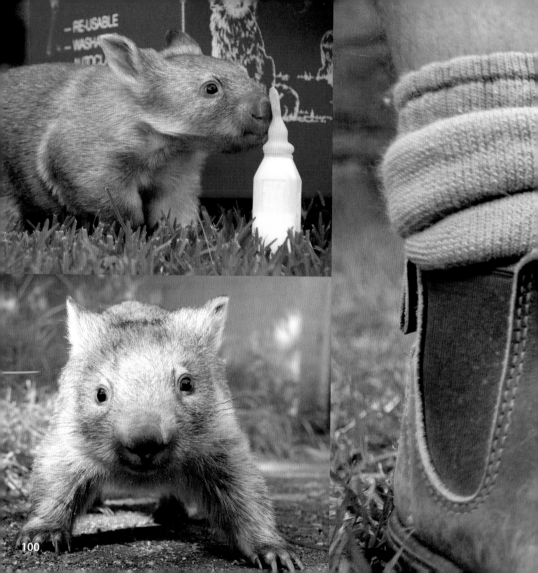

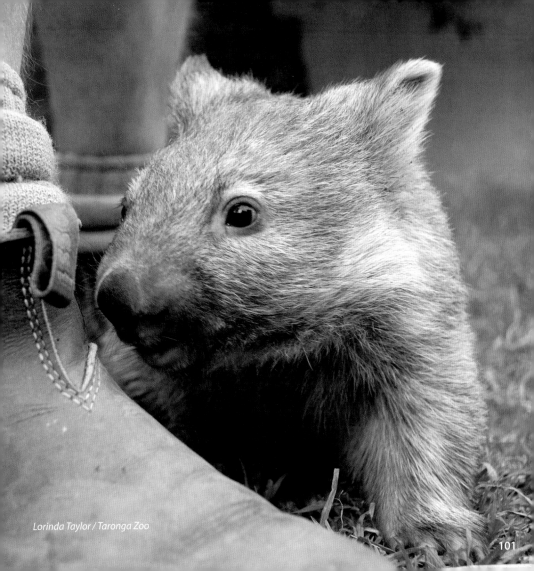

Lorinda Taylor / Taronga Zoo

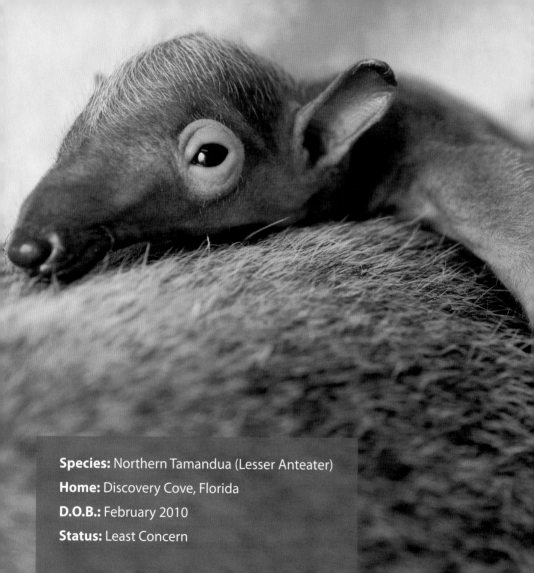

Species: Northern Tamandua (Lesser Anteater)
Home: Discovery Cove, Florida
D.O.B.: February 2010
Status: Least Concern

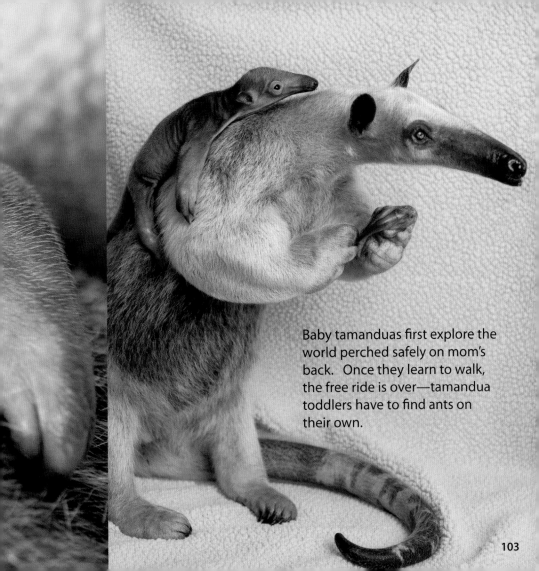

Baby tamanduas first explore the world perched safely on mom's back. Once they learn to walk, the free ride is over—tamandua toddlers have to find ants on their own.

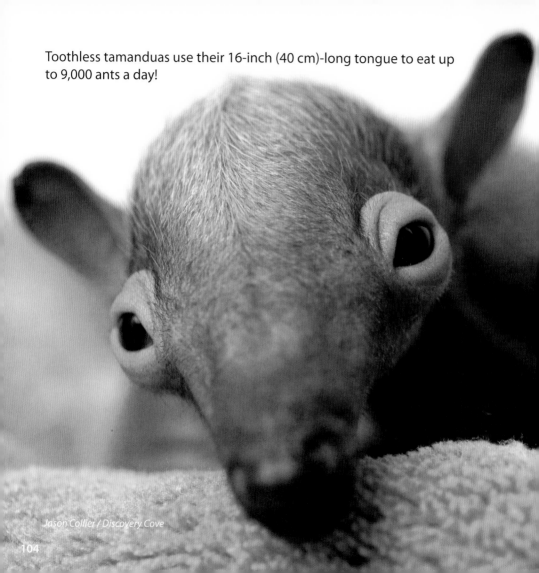

Toothless tamanduas use their 16-inch (40 cm)-long tongue to eat up to 9,000 ants a day!

Jason Collier / Discovery Cove

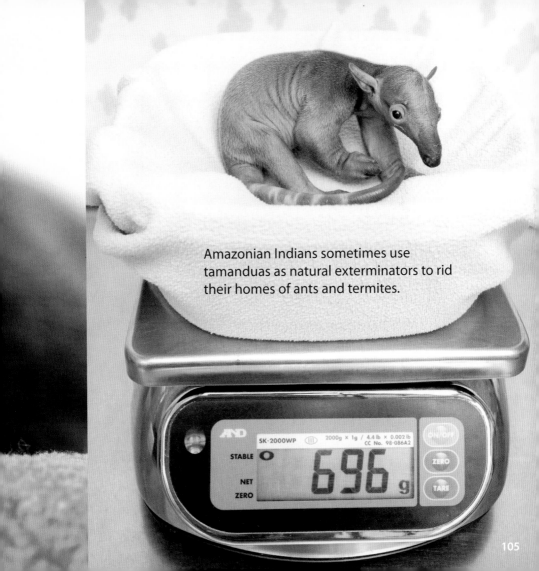

Amazonian Indians sometimes use tamanduas as natural exterminators to rid their homes of ants and termites.

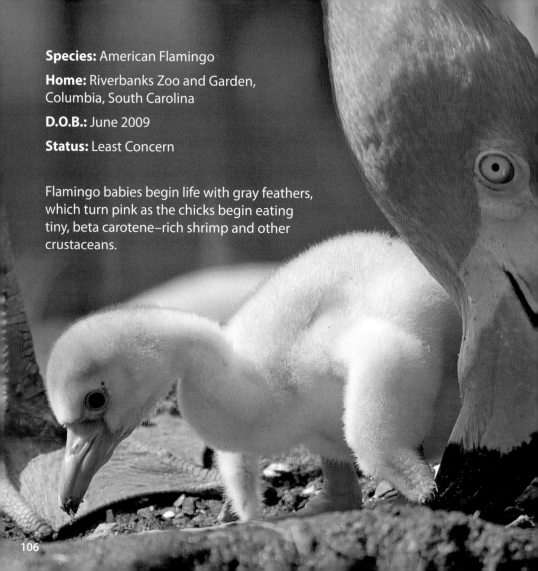

Species: American Flamingo

Home: Riverbanks Zoo and Garden, Columbia, South Carolina

D.O.B.: June 2009

Status: Least Concern

Flamingo babies begin life with gray feathers, which turn pink as the chicks begin eating tiny, beta carotene–rich shrimp and other crustaceans.

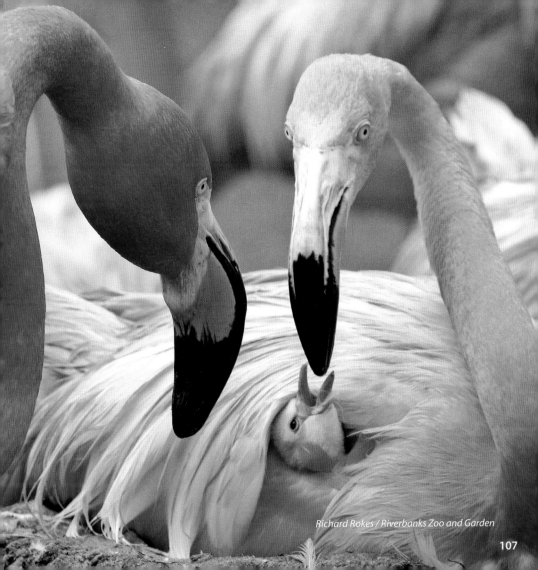

Richard Rokes / Riverbanks Zoo and Garden

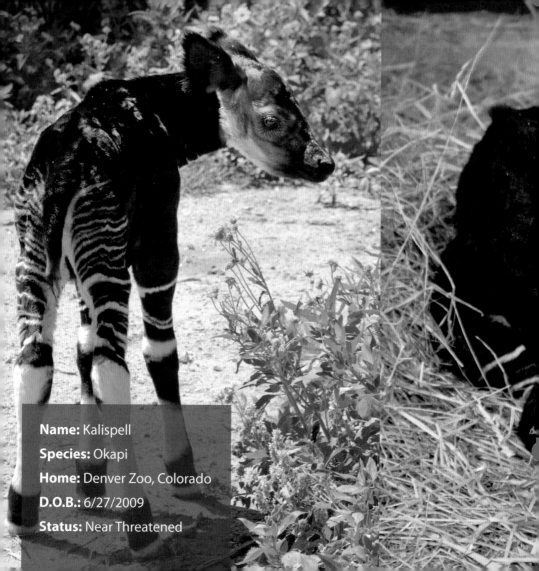

Name: Kalispell
Species: Okapi
Home: Denver Zoo, Colorado
D.O.B.: 6/27/2009
Status: Near Threatened

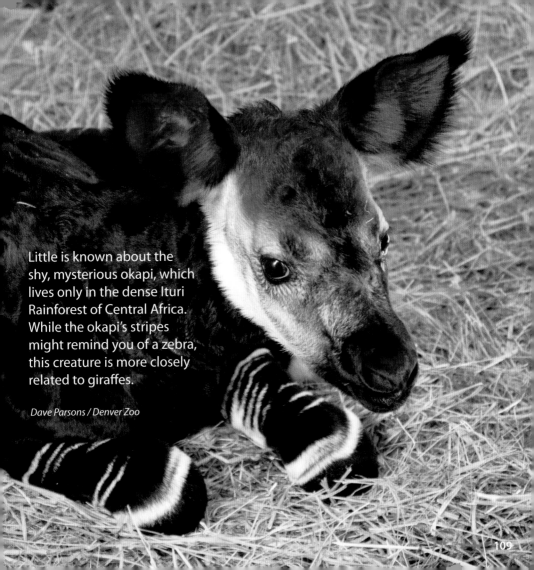

Little is known about the shy, mysterious okapi, which lives only in the dense Ituri Rainforest of Central Africa. While the okapi's stripes might remind you of a zebra, this creature is more closely related to giraffes.

Dave Parsons / Denver Zoo

109

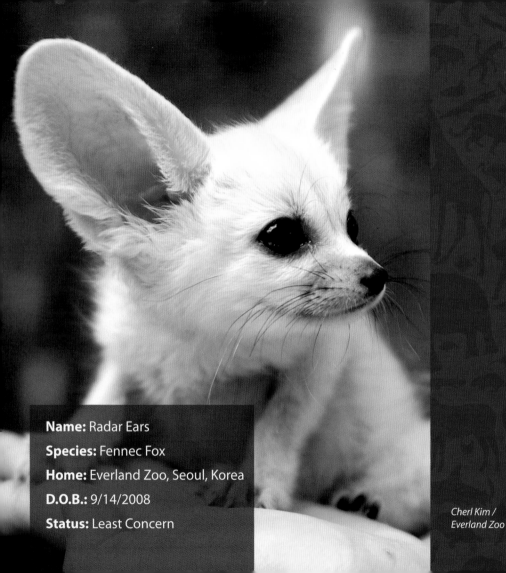

Name: Radar Ears
Species: Fennec Fox
Home: Everland Zoo, Seoul, Korea
D.O.B.: 9/14/2008
Status: Least Concern

*Cherl Kim /
Everland Zoo*

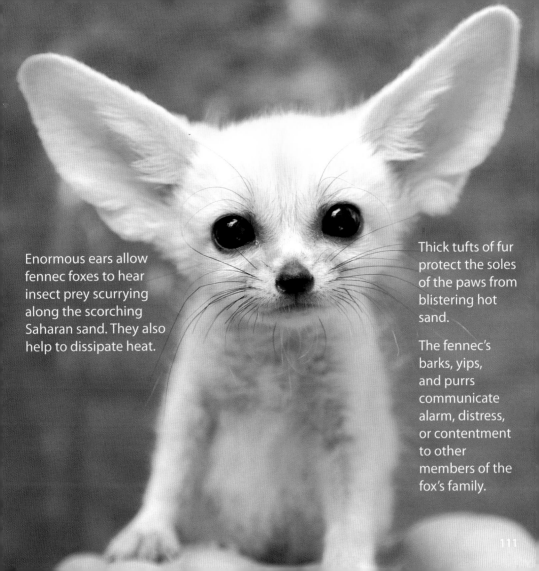

Enormous ears allow fennec foxes to hear insect prey scurrying along the scorching Saharan sand. They also help to dissipate heat.

Thick tufts of fur protect the soles of the paws from blistering hot sand.

The fennec's barks, yips, and purrs communicate alarm, distress, or contentment to other members of the fox's family.

111

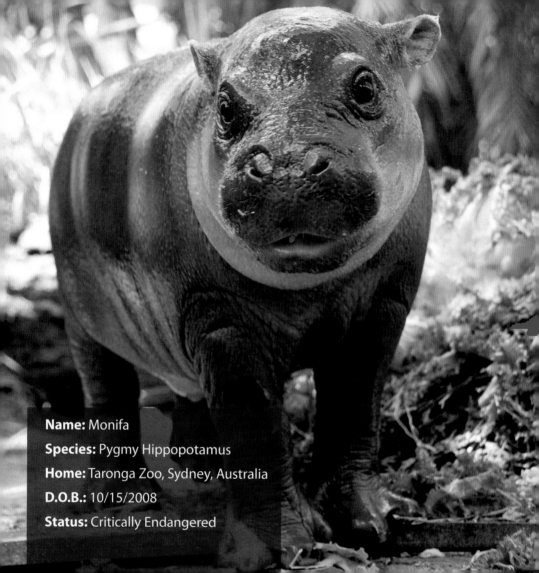

Name: Monifa
Species: Pygmy Hippopotamus
Home: Taronga Zoo, Sydney, Australia
D.O.B.: 10/15/2008
Status: Critically Endangered

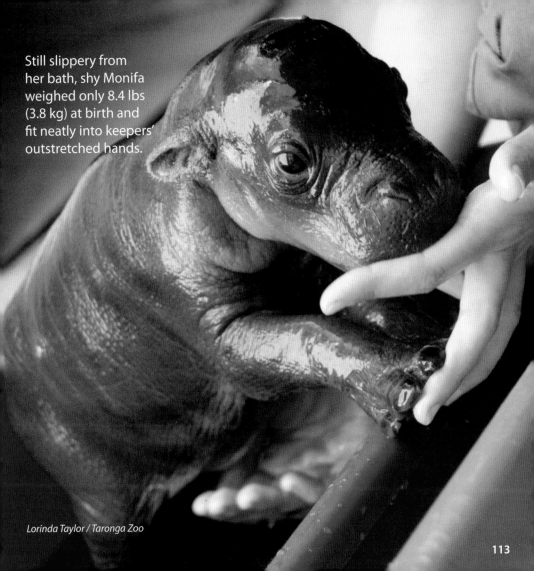

Still slippery from her bath, shy Monifa weighed only 8.4 lbs (3.8 kg) at birth and fit neatly into keepers' outstretched hands.

Lorinda Taylor / Taronga Zoo

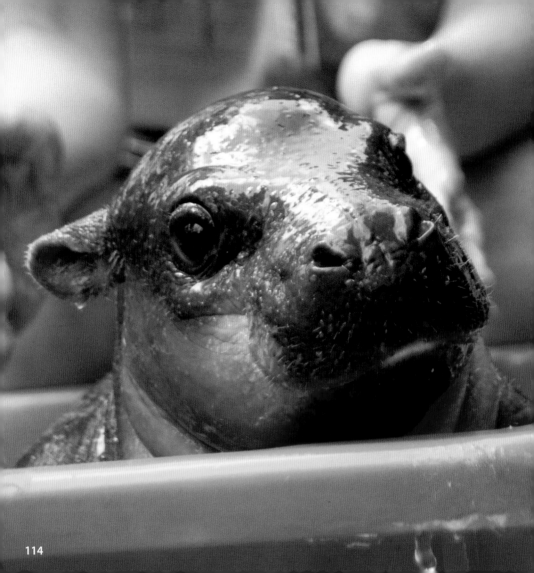

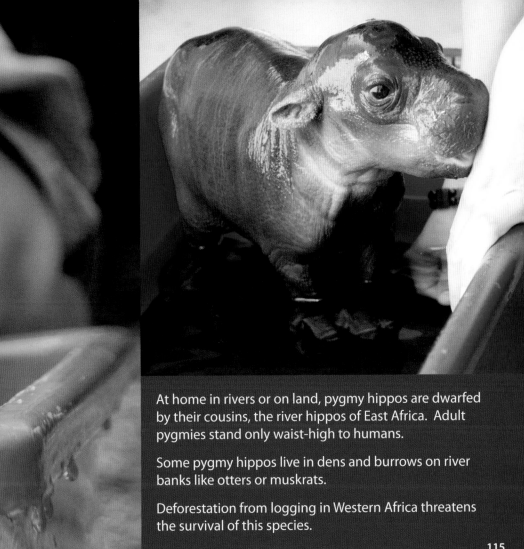

At home in rivers or on land, pygmy hippos are dwarfed by their cousins, the river hippos of East Africa. Adult pygmies stand only waist-high to humans.

Some pygmy hippos live in dens and burrows on river banks like otters or muskrats.

Deforestation from logging in Western Africa threatens the survival of this species.

Species: Asian Small-clawed Otter

Home: SeaWorld Orlando, Florida

D.O.B.: March 2009

Status: Vulnerable to Extinction

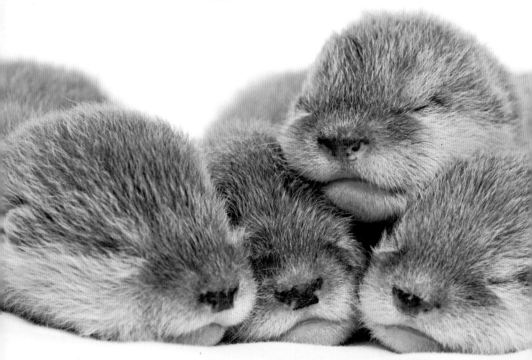

This pile of pups looks quiet for now, but they'll call out to parents Simon and Sophie with high-pitched, birdlike chirps!

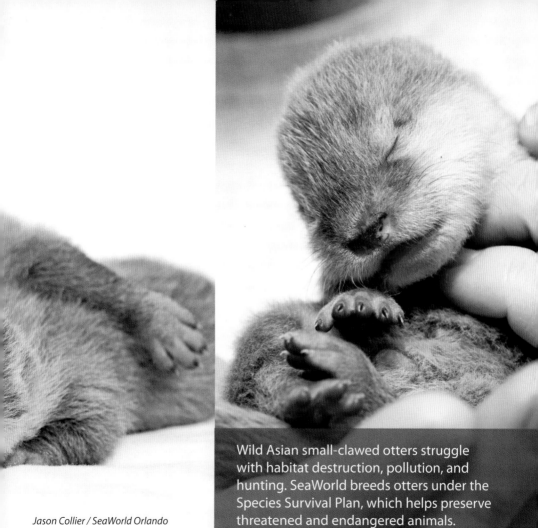

Jason Collier / SeaWorld Orlando

Wild Asian small-clawed otters struggle with habitat destruction, pollution, and hunting. SeaWorld breeds otters under the Species Survival Plan, which helps preserve threatened and endangered animals.

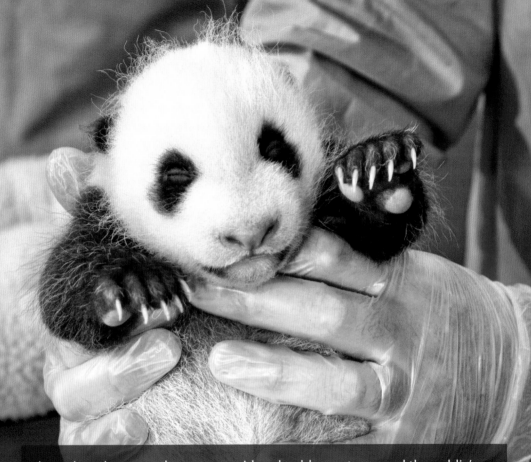

In ancient times, pandas were considered noble creatures, and the public's love affair with these roly-poly bamboo eaters continues today. The San Diego Zoo's little panda, Yun Zi, is a spirited, feisty little cub who loves wrestling with mom, Bai Yun.

Zoological Society of San Diego

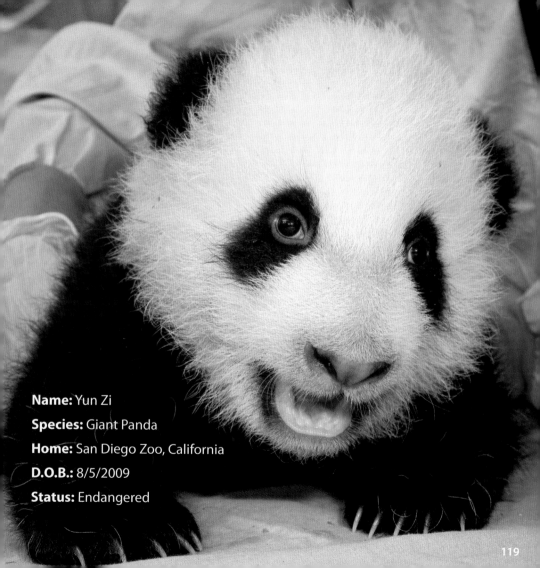

Name: Yun Zi

Species: Giant Panda

Home: San Diego Zoo, California

D.O.B.: 8/5/2009

Status: Endangered

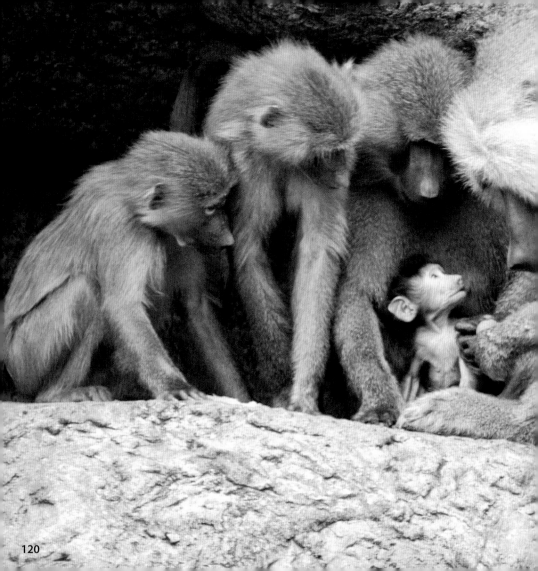

Name: Kito

Species: Hamadryas Baboon

Home: WCS's Prospect Park Zoo, NY

D.O.B.: 10/26/2005

Status: Least Concern

Kito and his older brother were the "terrible duo" of the baboon troop, constantly getting into mischief and annoying their elders. Of course, their antics were a delight to the public.

These two were also the most curious about zoo visitors, often sitting close to the glass viewing window and interacting with children.

Smaller groups of Hamadryas baboons will often join together to form bands of up to 200 individuals who travel and sleep together.

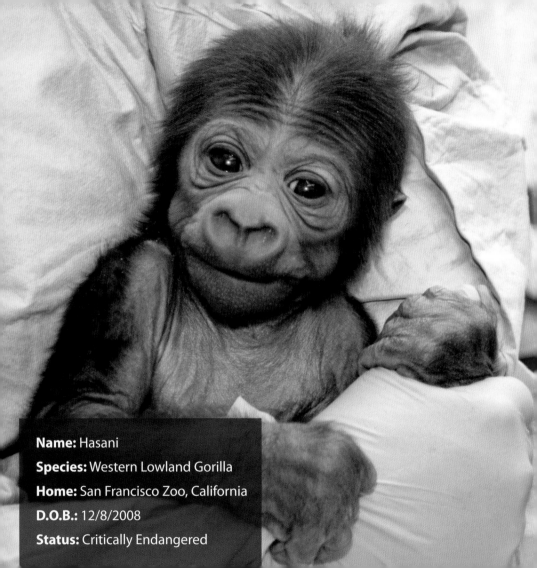

Name: Hasani

Species: Western Lowland Gorilla

Home: San Francisco Zoo, California

D.O.B.: 12/8/2008

Status: Critically Endangered

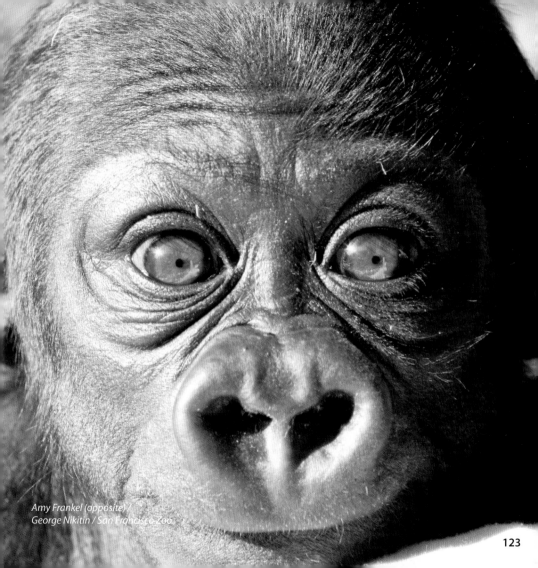

Amy Frankel (opposite) /
George Nikitin / San Francisco Zoo

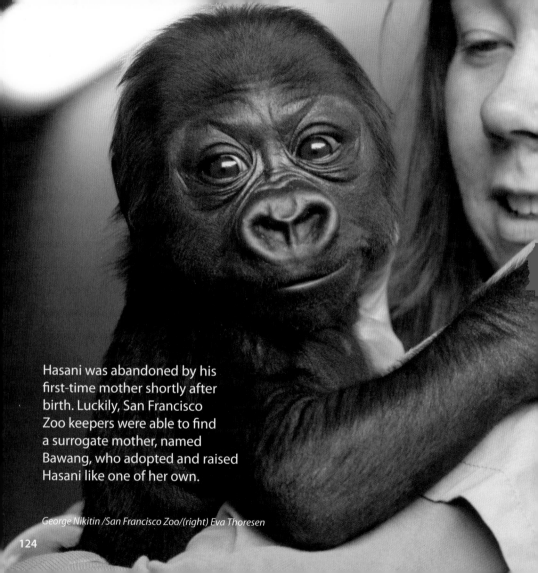

Hasani was abandoned by his first-time mother shortly after birth. Luckily, San Francisco Zoo keepers were able to find a surrogate mother, named Bawang, who adopted and raised Hasani like one of her own.

George Nikitin /San Francisco Zoo/(right) Eva Thoresen

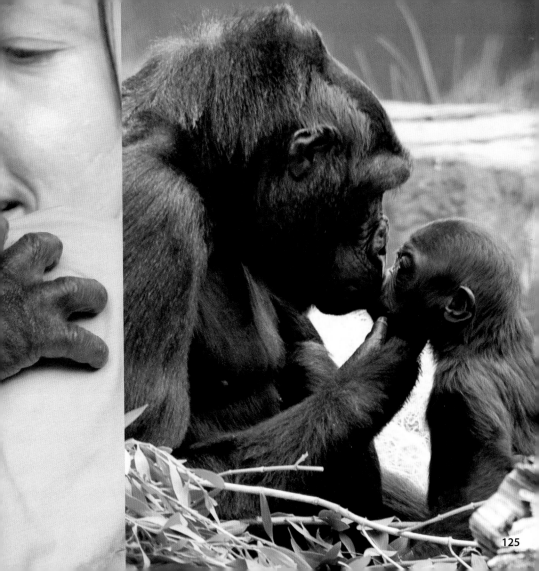

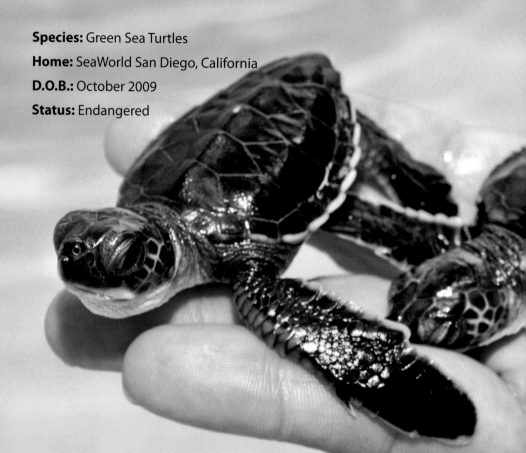

Species: Green Sea Turtles
Home: SeaWorld San Diego, California
D.O.B.: October 2009
Status: Endangered

Since these were wild sea turtles that were born on SeaWorld's Shipwreck Beach, it was up to the National Marine Fisheries Service and the U.S. Fish and Wildlife Service to determine the best home for them.

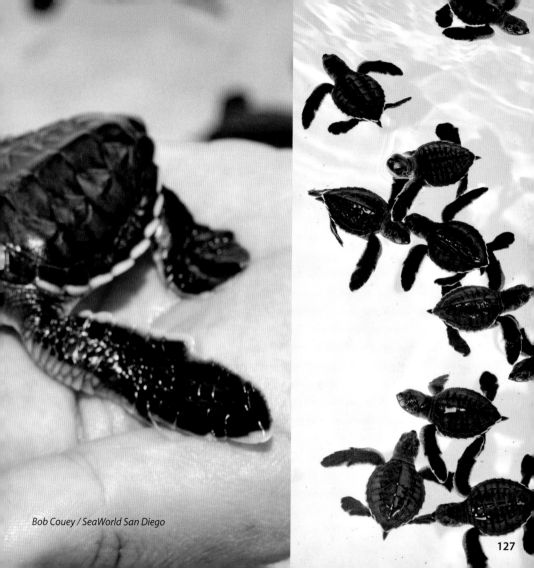

Bob Couey / SeaWorld San Diego

Species: Common Cuttlefish

Home: Smithsonian National Zoological Park, Washington, D.C.

D.O.B.: 2009

Status: Least Concern

Hundreds of tiny cuttlefish hatched at the Smithsonian's National Zoo in 2009. Please note, the penny is used for scale—*do not put pennies in your aquarium.*

When threatened, common cuttlefish squirt ink to create a smokescreen. The cuttlefish scoots off in the opposite direction, propelled by jets of water shot through its siphon.

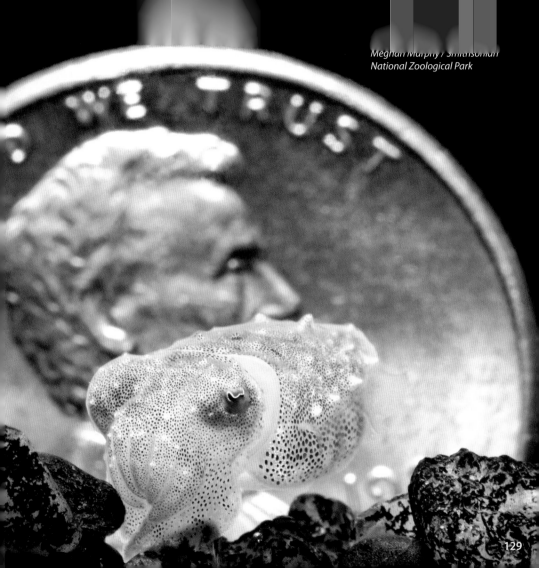

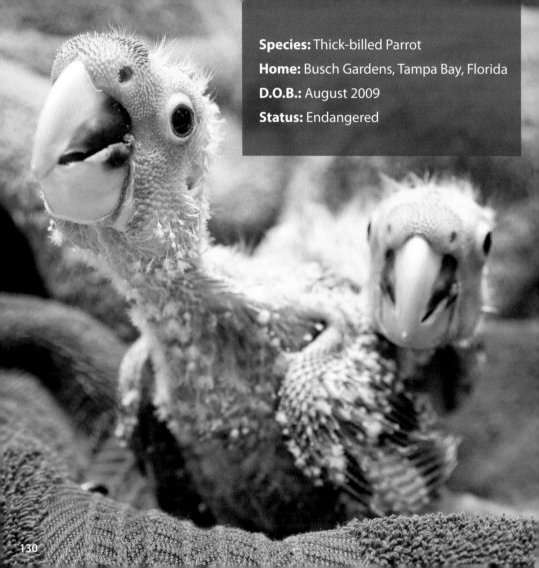

Species: Thick-billed Parrot
Home: Busch Gardens, Tampa Bay, Florida
D.O.B.: August 2009
Status: Endangered

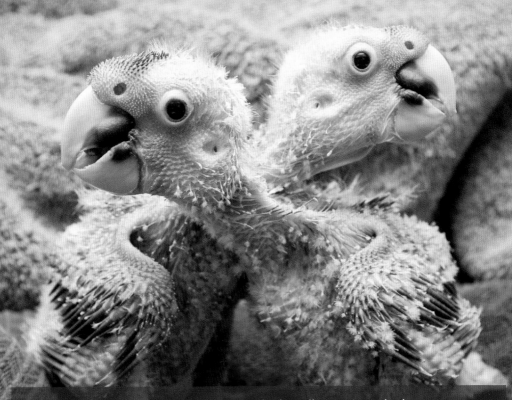

It's hard to believe that these scrawny chicks will grow into sleek green-feathered adults. As the last parrot species native to the United States, thick-billed parrots are endangered. Luckily, breeding programs in zoos maintain a stable population of these birds.

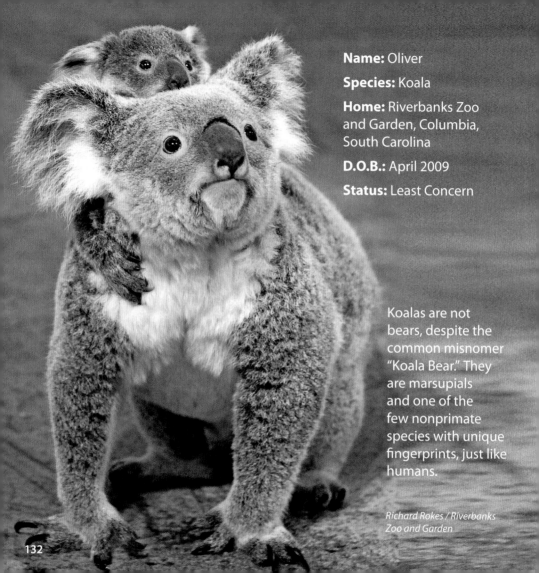

Name: Oliver

Species: Koala

Home: Riverbanks Zoo and Garden, Columbia, South Carolina

D.O.B.: April 2009

Status: Least Concern

Koalas are not bears, despite the common misnomer "Koala Bear." They are marsupials and one of the few nonprimate species with unique fingerprints, just like humans.

Richard Rokes / Riverbanks Zoo and Garden

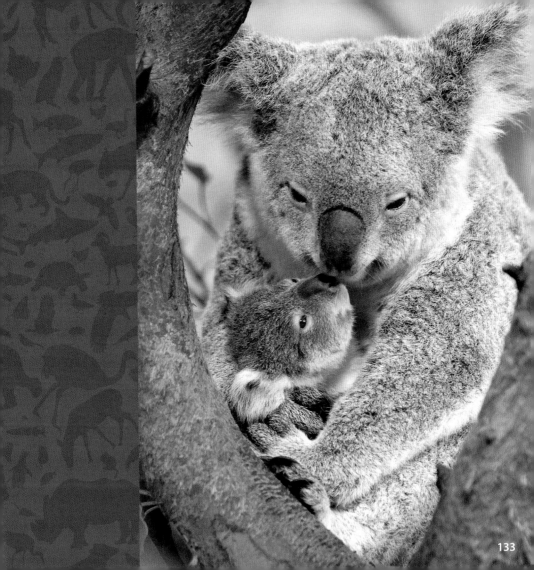

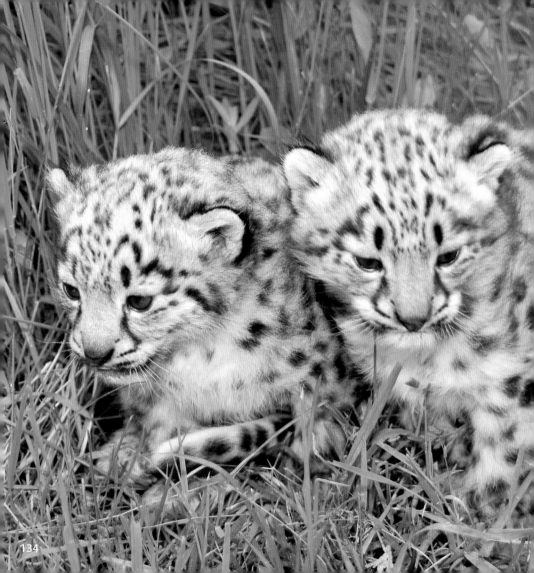

Name: Kira Victoria and Pasha Ryan

Species: Snow Leopard

Home: Toronto Zoo, Canada

D.O.B.: 5/16/2009

Status: Endangered

Thick fur, compact ears, and long bushy tails keep snow leopards toasty in their frosty, high-altitude, Himalayan homes.

Endangered in the wild, snow leopards may some day depend on the genetic diversity preserved at zoos and aquariums for their species' survival.

To deter poaching and incentivize snow leopard protection, the Toronto Zoo and the Snow Leopard Trust offer fair trade products made by people living in snow leopard habitats.

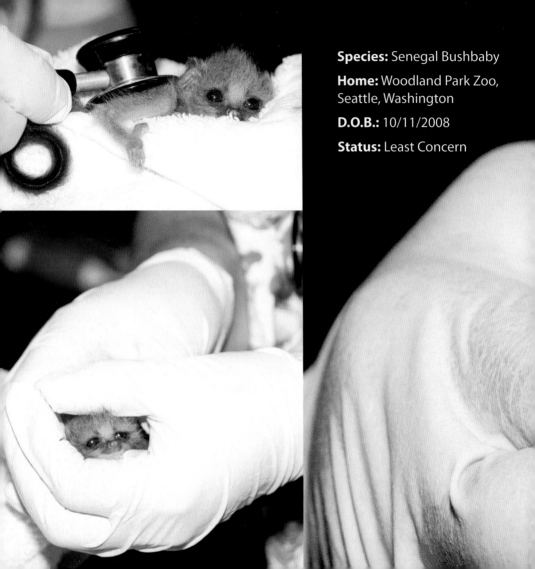

Species: Senegal Bushbaby

Home: Woodland Park Zoo, Seattle, Washington

D.O.B.: 10/11/2008

Status: Least Concern

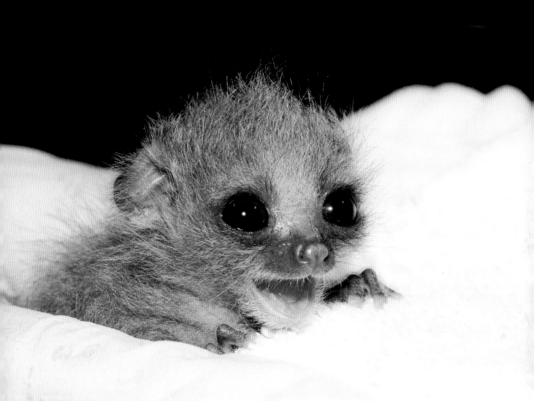

Also known as the Senegal galago, bushbabies are small, nocturnal primates that leap from branch to branch among the treetops.

Mother bushbabies carry their newborns in their mouths. When it's time for bed, bushbabies call out to one another and gather together to cuddle up as a group.

Ryan Hawk / Woodland Park Zoo

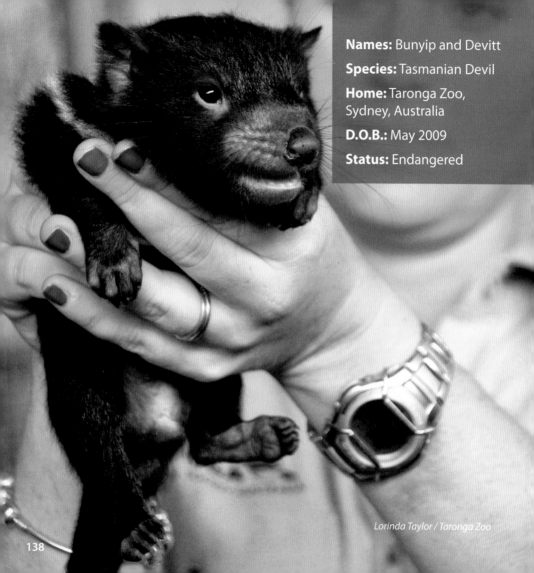

Names: Bunyip and Devitt
Species: Tasmanian Devil
Home: Taronga Zoo, Sydney, Australia
D.O.B.: May 2009
Status: Endangered

Lorinda Taylor / Taronga Zoo

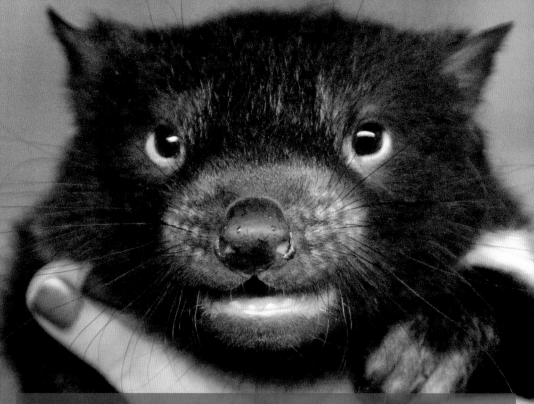

Ill-tempered and noisy while eating, Tasmanian devils live up to their feisty reputation. These small but muscular marsupials are found only on the Australian island of Tasmania.

Since the late 1990s, a mysterious transmissible cancer epidemic has devastated the wild Tasmanian devil population. The Taronga Zoo, with many other Australian partners, breeds Tasmanian devils on the mainland, to sustain the species should the wild population collapse as a result of the disease.

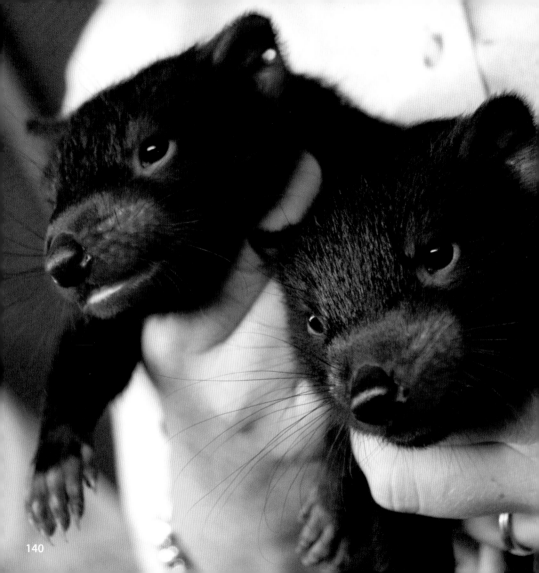

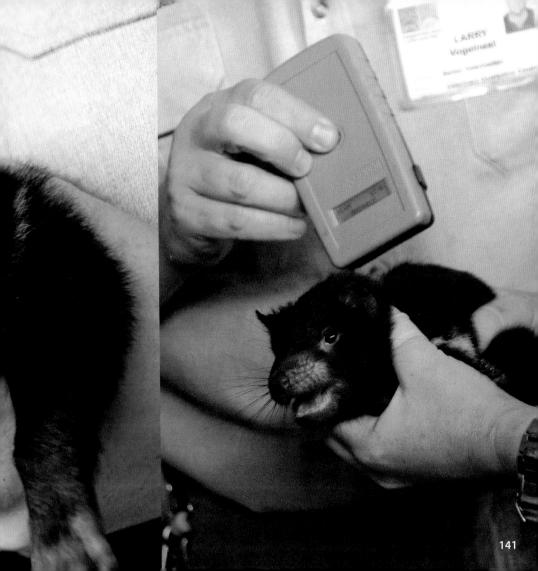

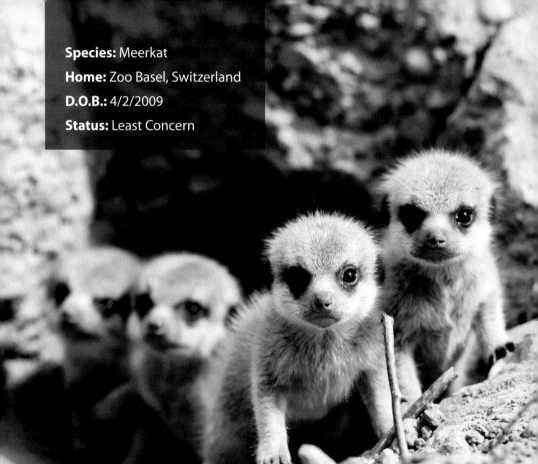

Species: Meerkat
Home: Zoo Basel, Switzerland
D.O.B.: 4/2/2009
Status: Least Concern

Cautiously crawling from their underground burrow, these meerkat pups take in their first view of the aboveground world.

Zoo Basel

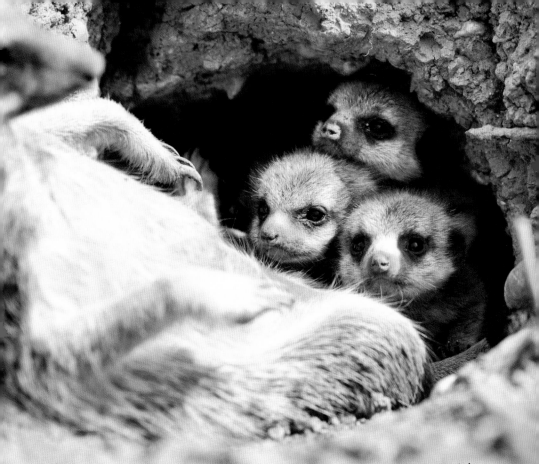

Highly social, meerkats form groups of twenty to thirty that maintain social bonds by grooming, scent-marking, and licking each other. Clan members take turns serving as sentries and babysitters. Meerkat pups are fiercely guarded by their entire clan.

INDEX BY ANIMAL

Aardvark, 42–43
American Flamingo, 106–7
Anteater, Lesser (Northern Tamandua), 102–5
Armadillo, Southern Three-banded, 94–95
Asian Elephant, 84–87
Asian Small-clawed Otter, 116–17
Aye-aye, 70–73

Baboon, Hamadryas, 120–21
Banded Mongoose, 18–21
Beluga Whale, 32–35
Bengal Tiger, 26–29
Bottlenose Dolphin, 96–97
Bushbaby, Senegal, 136–37

Chimpanzee, 88
Civet, Owston's Palm, 82–83
Clouded Leopard, 78–81
Columbia Basin Pygmy Rabbit, 90–93
Common Cuttlefish, 128–29
Common Wombat, 98–101
Crowned Sifaka, 54–57
Cuttlefish, Common, 128–29

Dolphin, Bottlenose, 96–97

Echidna, Short-beaked, 58–61
Elephant, Asian, 84–87
Emperor Tamarin, 62–65

Fennec Fox, 110–11
Flamingo, American, 106–7
Fox:
 Fennec, 110–11
 Swift, 8–9
Frogmouth, Tawny, 74–77

Gentoo Penguin, 14–15
Giant Panda, 118–19
Giraffe, 10–11
Gorilla, Western Lowland, 122–25
Green Sea Turtle, 126–27
Grevy's Zebra, 50–53

Hamadryas Baboon, 120–21
Hippopotamus, Pygmy, 112–15
Hyena, Spotted, 46–49
Hyrax, Rock, 66–67

Kangaroo, Red, 24–25
Kihansi Spray Toad, 89
Koala, 132–33

Lemur:
 Aye-aye, 70–73
 Crowned Sifaka, 54–57
Leopard:
 Clouded, 78–81
 Snow, 134–35

Lesser Anteater (Northern Tamandua), 102–5
Loggerhead Sea Turtle, 22–23

Marmot, Vancouver Island, 30–31
Meerkat, 142–43
Mongoose, Banded, 18–21

Northern Tamandua (Lesser Anteater), 102–5

Ocelot, 2–5
Okapi, 108–9
Orangutan, Sumatran, 6–7
Otter:
 Asian Small-clawed, 116–17
 Sea, 12–13
Owston's Palm Civet, 82–83

Panda:
 Giant, 118–19
 Red, 16–17
Parrot, Thick-billed, 130–31
Penguin, Gentoo, 14–15
Piping Plover, 41
Potto, 40
Pygmy Hippopotamus, 112–15

Rabbit, Columbia Basin Pygmy, 90–93
Red Kangaroo, 24–25
Red Panda, 16–17

Rhinoceros, White, 36–39
Rock Hyrax, 66–67

Sea Otter, 12–13
Sea Turtle:
 Green, 126–27
 Loggerhead, 22–23
Senegal Bushbaby, 136–37
Short-beaked Echidna, 58–61
Sifaka, Crowned, 54–57
Snow Leopard, 134–35
Southern Three-banded Armadillo,
 94–95
Spotted Hyena, 46–49
Sumatran Orangutan, 6–7
Swift Fox, 8–9

Tamandua, Northern (Lesser Anteater),
 102–5
Tamarin, Emperor, 62–65

Tasmanian Devil, 138–41
Tawny Frogmouth, 74–77
Thick-billed Parrot, 130–31
Tiger, Bengal, 26–29
Toad, Kihansi Spray, 89
Turtle:
 Green Sea, 126–27
 Loggerhead Sea, 22–23
 Western Pond, 68–69

Vancouver Island Marmot, 30–31

Western Lowland Gorilla, 122–25
Western Pond Turtle, 68–69
Whale, Beluga, 32–35
White Rhinoceros, 36–39
Wildcat, 44–45
Wombat, Common, 98–101

Zebra, Grevy's, 50–53

INDEX BY ZOO

Assiniboine Park Zoo, Canada, 25
Audubon Zoo, Louisiana, 7

Bronx Zoo, New York, 10, 89
Busch Gardens, Florida, 37, 51, 130

Calgary Zoo, Canada, 8, 30
Cincinnati Zoo and Botanical Garden, Ohio, 40
Connecticut's Beardsley Zoo, 3

Denver Zoo, Colorado, 46, 62, 70, 108
Detroit Zoo, Michigan, 42
Dierenpark Amersfoort, Netherlands, 88
Discovery Cove, Florida, 102

Edmonton Valley Zoo, Canada, 16
Everland Zoo, Seoul, Korea, 110

Fort Wayne Children's Zoo, Indiana, 18

Lincoln Park Zoo, Illinois, 41
Los Angeles Zoo, California, 67
Lowry Park Zoo, Florida, 26

Melbourne Zoo, Australia, 85
Minnesota Zoo, Minnesota, 94
Monterey Bay Aquarium, 12

Musée de Besançon, France, 54
Newquay Zoo, United Kingdom, 83

Opel Zoo, Germany, 45
Oregan Zoo, Oregon, 90

Perth Zoo, Australia, 58
Prospect Park Zoo, New York, 121

Riverbanks Zoo and Garden, South Carolina, 106, 132

San Diego Zoo, California, 119
San Francisco Zoo, California, 122
SeaWorld Orlando, Florida, 22, 74, 116
SeaWorld San Diego, California, 14, 97, 126
Shedd Aquarium, Illinois, 33
Smithsonian National Zoological Park, Washington, D.C., 78, 128

Taronga Zoo, Australia, 99, 112, 138
Toronto Zoo, Canada, 135

WCS's Bronx Zoo, New York, 10, 89
WCS's Prospect Park Zoo, New York, 121
Woodland Park Zoo, Seattle, Washington, 69, 137

Zoo Basel, Switzerland, 142

Thanks to the institutions and inviduals that made *ZooBorns* possible:

Akron Zoo
Antwerp Zoo
Apenheul Primate Park
Aquarium of the Bay
Artis Zoo
Assiniboine Park Zoo
Auckland Zoo
Audubon Zoo
Aviarios Sloth Sanctuary
Belfast Zoo
Belgrade Zoo
Berlin Zoo
Binder Park Zoo
Blackpool Zoo
Bramble Park Zoo
Brevard Zoo
Bristol Zoo Gardens
Brookfield Zoo
Buffalo Zoo
Burgers Zoo
Busch Gardens
Calgary Zoo
Capron Park Zoo
Central Florida Zoo
Chessington Zoo
Chester Zoo
Chiang Mai Zoo
Chilean National Zoo
Cincinnati Zoo
Cleveland Metroparks Zoo
Colchester Zoo

Columbus Zoo & Aquarium
Como Zoo
Connecticut's Beardsley Zoo
Darmstadt Zoo
Denver Zoo
Detroit Zoo
Dierenrijk Europa Zoo
Diergaarde Blijdorp
Discovery Cove
Disneyís Animal Kingdom
Dortmund Zoo
Dreamworld Australia
Dresden Zoo
Dublin Zoo
Dusit Zoo
Edinburgh Zoo
Edmonton Valley Zoo
Everland Zoo
Florida Aquarium
Fort Wayne Children's Zoo
Frankfurt Zoo
Franklin Park Zoo
Georgia Aquarium
Hagenbeck Zoo
Hamilton Zoo
Happy Hollow Zoo
Hogle Zoo
Honolulu Zoo
Houston Zoo
Indianapolis Zoo
Jacksonville Zoo

Jerusalem Biblical Zoo
Jurong Bird Park
Kangaroo Conservation Center
Kansas City Zoo
Knoxville Zoo
Kolmarden Zoo
Lakes Aquarium
Lee Richardson Zoo
Lincoln Childrenís Zoo
Lincoln Park Zoo
Lion Country Safari
Living Coasts Zoo
Longleat Safari Park
Los Angeles Zoo
Louisville Zoo
Lowry Park Zoo
M'Bopicu· Breeding Station
Marwell Park Zoo
Maryland Zoo
Melbourne Zoo
Memphis Zoo
Mesker Park Zoo
Mexicali Zoo
Miami Metrozoo
Milwaukee County Zoo
Minnesota Zoo
Mogo Zoo
Monkholm Zoo
Monterey Bay Aquarium
Moody Gardens
Munster Zoo

Musée de Besançon
Mystic Aquarium
Naples Zoo
Nashville Zoo
National Aquarium in Baltimore
New York Aquarium
Newport Zoo
Newquay Zoo
Niabi Zoo
North Carolina Aquarium at Pine Knoll Shores
North Carolina Zoo
Northeastern Wisconsin Zoo
Odense Zoo
Oklahoma City Zoo
Omaha's Henry Doorly Zoo
Opel Zoo
Oregon Zoo
Osaka Aquarium Kaiyukan
Ouwehands Zoo
Paignton Zoo
Palm Beach Zoo
Park of Legends
Perth Zoo
Philadelphia Zoo
Phoenix Zoo
Pittsburgh Zoo
Planckendael Zoo
Potter Park Zoo
Puerto Vallarta Zoo
Red River Zoo

Rio Grande Zoo
Riverbanks Zoo
Romeís Biopark Zoo
Rosamond Gifford Zoo
Rotterdam Zoo
Saint Louis Zoo
Salisbury Zoo
San Diego Zoo
San Francisco Zoo
Santa Barbara Zoo
Schwerin Zoo
SeaWorld Orlando
SeaWorld San Diego
Shedd Aquarium
Singapore Zoo
Smithsonian National Zoo
Southwick's Zoo
St. Augustine Alligator Farm Zoological Park
Stone Zoo
Sunshine International Aquarium
Tallinn Zoo
Tama Zoo
Taronga Zoo
Toledo Zoo
Toronto Zoo
Trotter's World
Tulsa Zoo
Twycross Zoo
Ueno Zoo
Virginia Zoo

WCS's Bronx Zoo
WCS's Prospect Park Zoo
WCS's Queens Zoo
Wellington Zoo
Wildlife Heritage Foundation
Wildlife World Zoo
Wilhelma Zoo
Wingham Wildlife Park
Woodland Park Zoo
Wuppertal Zoo
Zoo Atlanta
Zoo Basel
Zoo BoissiÈre
Zoo Morelia
Zoo New England
Zoo Zurich
ZooAmerica
ZSL London Zoo
ZSL Whipsnade Zoo

Special thanks to Cheryl Piropato for her attention to the copy.

About the Authors

Andrew Bleiman spends his days working in new media strategy and nights dreaming of ways to spend more time at zoos and aquariums. He graduated from the University of Pennsylvania with a degree in English literature and a yet to be recognized minor in baby animal-ology. Andrew lives in Chicago, Illinois, with his wife, Lillian, and their dogs, Izzy and Mathman.

Chris Eastland is a classically trained portrait artist and a freelance web and graphic designer. While Chris loves all the ZooBorns, he's particularly partial to primates and cats. He lives in Brooklyn with his wife, Joëlle, and their two cats, Geogie and Laika.

Andrew and Chris share a passion for connecting people and animals, and with *ZooBorns* they hope to raise awareness of the vital role zoos and aquariums play in conservation. To learn more about the animals in this book—and to meet even more zoo babies—visit their website, ZooBorns.com.